FASHION

ILLUSTRATION ART

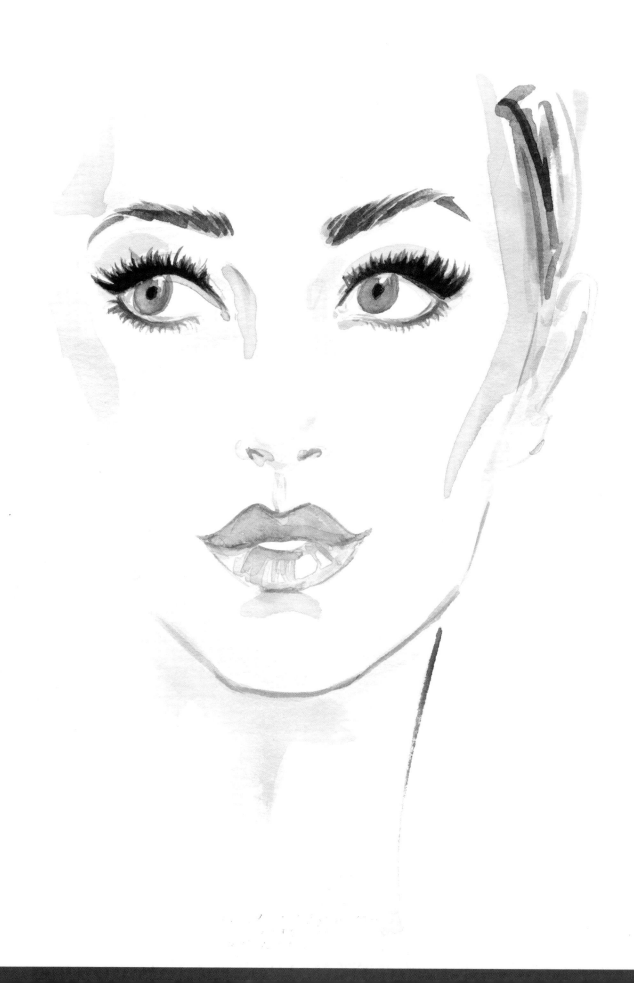

FASHION
ILLUSTRATION ART

HOW TO DRAW FUN & FABULOUS FIGURES, TRENDS & STYLES

JENNIFER LILYA

NORTH LIGHT BOOKS
CINCINNATI, OHIO

artistsnetwork.com

Contents

Introduction **6**

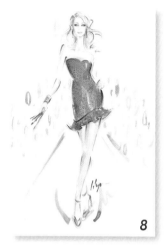

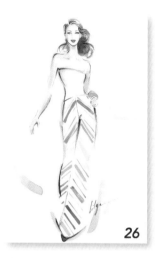

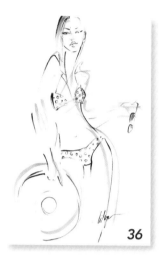

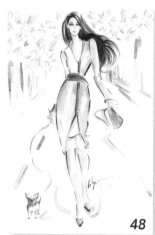

8

26

36

48

CHAPTER 1
Tools, Tips and
Techniques

CHAPTER 2
Balancing
the Figure

CHAPTER 3
Gesture
Painting

CHAPTER 4
Movement and
Exaggeration

WHAT YOU NEED

SURFACE
Stonehenge paper

PIGMENTS
assortment of acrylic paints including
Titanium White, Cadmium Orange (for
outlines) and Dioxazine Purple (for shadows)
metallic paints
black permanent ink

BRUSHES
nos. 000 to 12 rounds

OTHER TOOLS
small porcelain palette for mixing inks

large porcelain palette for mixing acrylics

water jars and spray bottle

paper towels

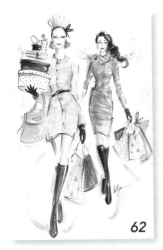

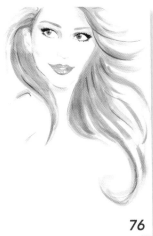

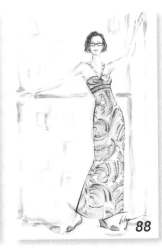

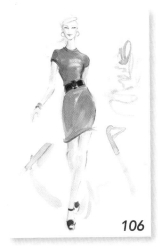

CHAPTER 5 62
Line Quality

CHAPTER 6 76
Faces

CHAPTER 7 88
Fabric and
Accessories

CHAPTER 8 106
Demos, Gallery and
Templates

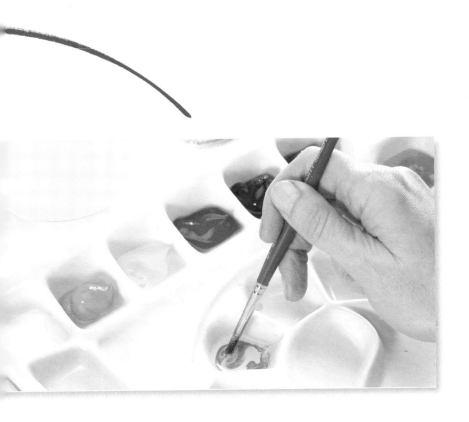

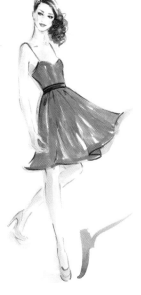

Index **126**
About the Author **127**

Introduction

I love painting pretty pictures! It sounds so simple, but those few words sum up my world of fun, fabulous fashion illustration. I grab my paint and brushes and completely lose myself in colors, silhouettes and beauty.

I fell in love with the art of fashion illustration long before I realized it was a thing. My eyes were always drawn to the gorgeous brushstrokes and expressive beauty found in traditional fashion illustration. The magazine advertisements of the '70s and '80s that contained illustrative work were always my absolute favorite. I would spend countless hours tracing, practicing and emulating the art that I found to be so pretty and compelling. I was always the kid in class who could draw, but to turn those childhood doodles into a lifelong career is a dream come true.

The artists who inspired me when I was a kid—Antonio Lopez, René Gruau, Carl Erickson, Tony Viramontes and countless others—are still the artists who inspire me to this day. To think that I've made a name for myself in the wonderful world of fashion illustration makes me happier than I ever thought I could be. My ten-year-old self would be freaking out with joy to know that I would be painting my Barbie dolls all day long when I was a grown-up!

I spend each day painting pretty people in their whimsical worlds—sometimes real, sometimes a complete fantasy, but both are fabulously fun. Many people have asked me to teach classes or write a book, but I never really had the time to take on such a huge personal project. When I got a call from F+W, I knew that I had to jump in with both feet and just do it!

I'll admit it was challenge finding the time to work on the book in between other client projects, some-times grasping for inspiration at 3:00am and trying to find the right words to use to make verbal sense of what I do instinctively. My goal was to turn my fashion illustration methods into lessons that will help you, the reader, all while making them fun, exciting and inspiring so that you want to do nothing but paint pretty pictures all day long. I hope you find this mission accomplished!

The lessons in this book are what I do from start-to-finish to create my Lilya Girls. I've broken down my process by how I portion out my day-to-day projects. We'll start with the supplies you need to get started as well as the basics of color, skin tones, anatomy and balance. Then we'll warm up with gesture paintings and practice expressive lines and brushwork to master the lively movement so instrumental in fashion illustration. Finally we will practice the details and finishing touches that complete a piece and make it truly magical.

I hope you have as much fun painting with this book as I do painting in my studio each day. Approach your art career with seriousness, but remember that fashion is also light-hearted, sweet, pretty, fun and visually exciting. Keep that in mind and your girls will start to come to life in perfect worlds of your own!

xoxo

Lilya

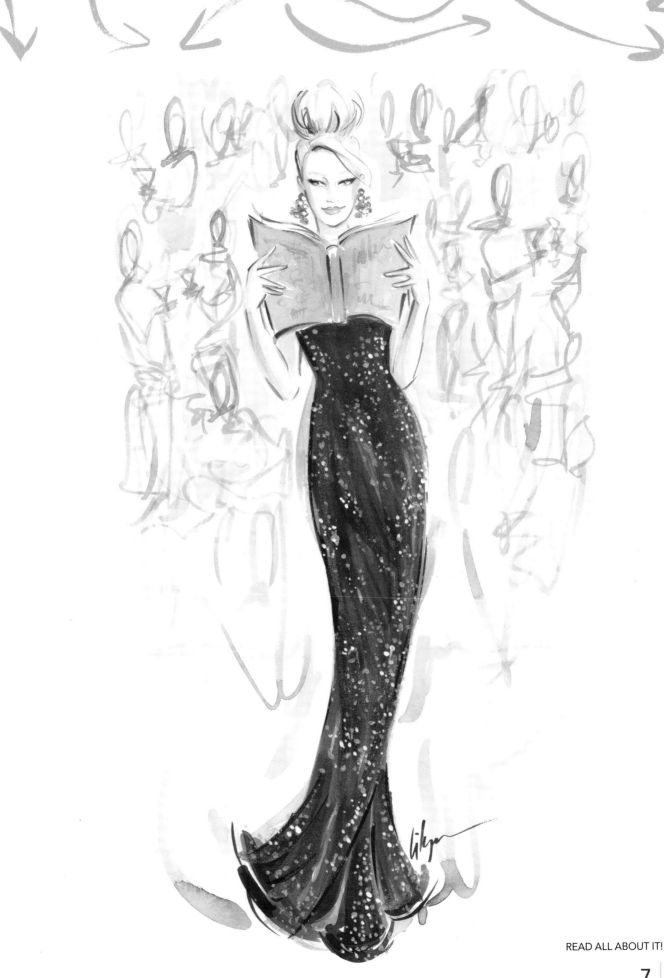

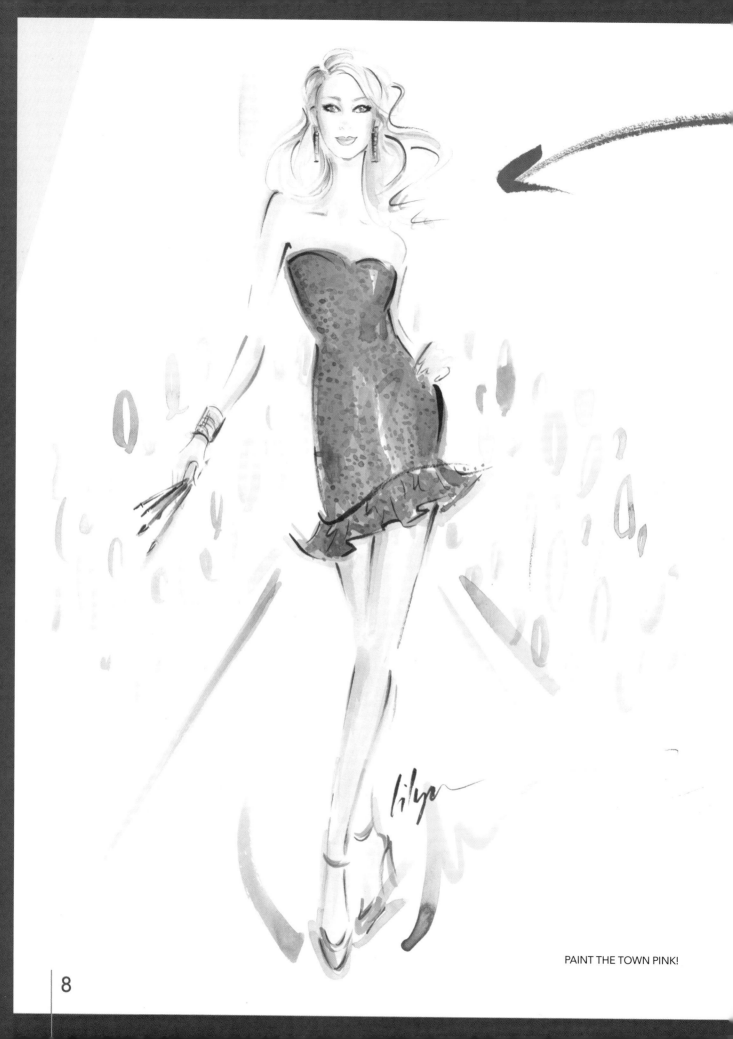

TOOLS, TIPS & TECHNIQUES

SKYLAR

Just as a chef prepares her ingredients, tools and equipment to create a delicious recipe, my *mise en place* consists of paints, brushes and paper to create pretty paintings. Before I even set brush to paper, I set my drawing board up with a rainbow of colors, supplies and inspiration, which you'll find inside this chapter. It's taken me years to discover and perfect my favorite color palette, my favorite brands of paints and paper, and especially my favorite brushes. This chapter provides an easy guide that can be altered to suit your own illustration needs. I suggest you experiment with a variety of colors and tools to enhance your creativity and find your very own *mise en place*.

Painting Supplies

Brushes and Brush Care

There are many sizes, shapes and brands of brushes, but my personal favorite is the quite affordable Winsor & Newton University Series. These synthetic brushes are sturdy enough for heavy acrylics and fine enough to create a watercolor effect on paper.

I use only round brushes. They creates perfect lines for fashion—anything from a delicate, pointed eyelash to covering a large background of color in one stroke.

There's no need to spend money on expensive brush cleaners; just use a gentle shampoo straight from your shower. Clean your brushes about once a week to rid them of the paint and ink that build up at the base. Gently suds up your brushes with lukewarm water and shampoo in the palm of your hand, swirling them around to remove any dried paint. Be sure to rinse them thoroughly and use your fingers to reshape each brush into a point before it dries.

Acrylic Paint

Many people think that I work in watercolor and are surprised to hear that my illustrations are created in acrylic and black ink. I love a watercolor effect, but I don't like how watercolors are still blendable on paper. I want my brushstrokes to be quick and fresh. Once acrylics dry on paper, they're water resistant and can't be changed. This allows me to layer color upon color without worrying about them turning into mud or tearing up the paper with too much blending. Experiment with acrylics. You'll find that you can create a whisper soft wash all the way to a deeply textured surface. I tend to stay on the watercolor-effect side of acrylics—I prefer fashion to be on the light and whimsical end of the spectrum, and acrylics allow me to achieve this.

MY BRUSHES

Here are the sizes I use on a daily basis. You may wonder why there are usually more brushes in my studio photos. I typically use multiples of many sizes at once—one for lighter colors and one for dark colors and ink. This helps to keep the lighter colors as fresh as possible on the brush without a lot of washing in between painting. It's a time-saver as well as a brush-saver.

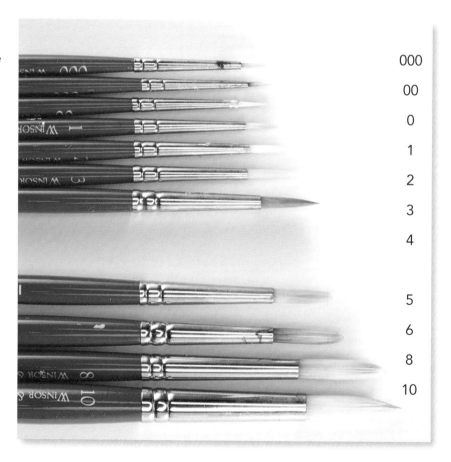

000
00
0
1
2
3
4
5
6
8
10

Waterproof Drawing Ink

I've always loved working in ink, especially during my days at the Fashion Institute of Technology (FIT). We'd experiment with a wide spectrum of ink washes during our life-drawing sessions, and those lessons are still with me to this day. I find that black ink has more depth and character than black acrylic does— it just goes down on the paper in such an intense way. The black liquid slides elegantly off the brush, creating perfectly clean lines to detail your paintings. The ink can also be watered down to just the slightest hint of gray—which is what I use to sketch my gestures. Play around with ink and water and you'll discover what a wide range of uses ink has.

The Perfect Palette

Before I discovered my perfect palette, I blended my paints in butcher trays. They were passable, but colors would bleed into each other and be wasted at the end of the day. I now use a large porcelain palette and a smaller ten-well mixing palette. The large palette separates all of my colors with plenty of smooth space for mixing. It also holds my small palette of ink, which I like to keep separate from the acrylics. The best part is that once the palette is covered, the acrylics will last for about two to three weeks before I need to clean and refresh the palette. This has saved me hundreds of dollars throughout the years because tubes of paint now last for years rather than months. It's well worth the initial investment for a lifetime of savings in paint.

I use many smaller mixing palettes throughout an average day. To keep the waste of black ink to a minimum, I use a small dropper bottle of Higgins ink to absorb any leftover ink and later squirt it into a fresh mixing palette. Less waste is more money saved in the long run.

Paper

There are tons of paper options to choose from, but my absolute favorite is Stonehenge. It has a smooth finish with just enough of a tooth that

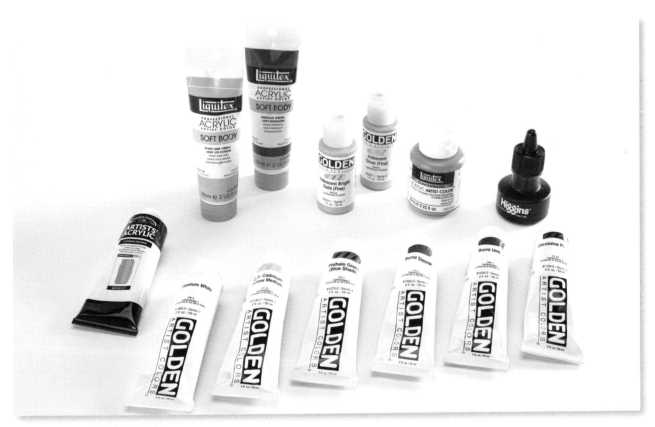

ACRYLIC PAINTS AND INK

Visit artistsnetwork.com/fashionart to download free video demonstrations by Jennifer Lilya.

11

it doesn't absorb paint too quickly. This limits the amount of bleeding your paint will do, and creates just enough texture that your ink lines will be greatly enhanced. You'll want to experiment with different surfaces and weights. You may enjoy the slickness of hot press or the deep textures of cold-pressed paper or any of the many options in between.

Choose a paper size you're comfy working on. You don't want to intimidate yourself with the stress of painting something very large and covering a big space. On the other hand, don't work so small that you tighten up your lines and hinder your natural painting style. I find 11" × 14" (28cm × 36cm) to 11" × 17" (28cm × 43cm) are great sizes to start with. And you can easily tear them in half for smaller sizes.

Water Jars and Spray Bottle

You're going to need empty jars for clean water. I find that old pickle jars work great, but anything that has a wide mouth will work. I normally have between four and six jars of water placed toward the back of my palette because I don't want to interrupt a good line or painting groove by having to go to the kitchen frequently for fresh water. I use specific jars for light colors, dark colors, metallics and my base tone of oranges. This works as a great time-saver for me and helps keep my supplies clean and organized.

Have a spray bottle filled with water nearby to keep your paints moist and to clean your palette quickly.

Paper Towels

You'll need a roll of white paper towels to blot your brushes and wipe your palettes clean. If you're working on a full piece of paper, place a paper towel underneath the hand you're painting with. This will help to lessen smudges and save the tooth of the paper from your natural skin oils and movement over the paper.

I also recycle the paper towels. I blot my brushes and use them to clean my palettes. I let them dry and put them in a drawer so I can quickly grab them in a pinch.

Scrap Paper

Save and reuse all of your ripped up paintings as scrap paper. I have a drawer full of ripped paper right by my drawing table that I use to test paint colors. You want this to be the same paper you're working on. I save any mistakes on paper I've used for lettering and use the backs of that to test on since my paper is similar on both sides. I recycle it before it even goes into the recycling bin!

Recycling Setup

Recycle any and all materials where you can. I have two separate trash bins under my drawing table, one for actual trash and one for paper recycling that I use for drawing paper, scrap paper for making notes and magazine reference tears, and the pile of magazines I get in the mail each month. I also donate paintbrushes and some paints to kids or art students. What might not be suitable for you anymore can be perfect for somebody else in need—even if it's just for practice use.

CREATING A HEALTHY WORKSPACE

Good lighting is key. Natural light is amazing, but it lasts only part of a day. I have three drawing lamps on my table along with two standing lamps in my studio. Good light makes it easier to work, see clean colors and relieves eye strain. Even if it's a super sunny day, I have my drawing lamps on so when day turns to night, my lighting will still be the same as will the consistency of my illustrations. Good posture and lumbar support pillows will help you work through the night on long projects or quick deadlines. You may not have back problems now, but sitting in one position for hours on end isn't the healthiest and can catch up to you. Remember to take stretching breaks, get up from your table and walk around. It refreshes the mind as well as the body.

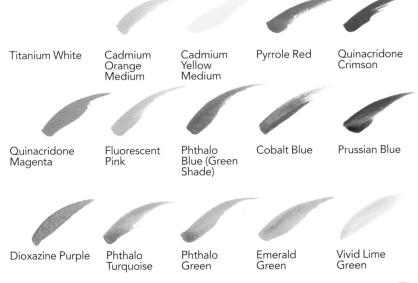

Titanium White

Cadmium Orange Medium

Cadmium Yellow Medium

Pyrrole Red

Quinacridone Crimson

Quinacridone Magenta

Fluorescent Pink

Phthalo Blue (Green Shade)

Cobalt Blue

Prussian Blue

Dioxazine Purple

Phthalo Turquoise

Phthalo Green

Emerald Green

Vivid Lime Green

Burnt Sienna

Burnt Umber

Iridescent Gold (Fine)

Iridescent Silver (Fine)

black drawing ink

MY EVERYDAY RAINBOW

Here are the colors I use in my daily palette, shown clockwise starting in the lower left of the palette below. I place the gold and silver metallic paints, and black ink mixed with water in a smaller palette. Experiment with a palette setup that works for you!

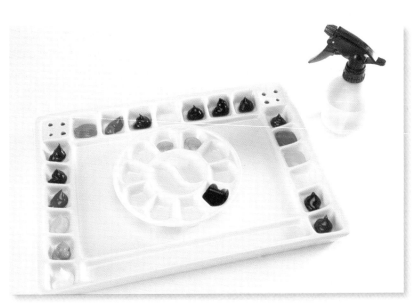

MY PALETTE SETUP

BLACK INK BASICS

The only black I use is straight out of the bottle. If I'm painting a black-toned garment, I'll add either red paint or blue paint to the ink to create a livelier black hue. I use red for warmer illustrations and blue for cooler illustrations. It makes a big difference when balancing the overall piece. If you paint black ink without mixing it first, it will create a "black hole" on the paper that can look off or jarring.

Color Theory

I'm sure a lot of you are familiar with the classic color wheel or at least remember it from elementary school art class. It's a visual tool that organizes color by hue and illustrates the relationships between primary, secondary, tertiary and complementary colors. Sir Isaac Newton invented the first circular color diagram way back in 1666, and it's still in use today in all of its various forms. I illustrate the wheel as a color blossom because I like to keep things pretty and fun while we're learning. Let's break down the petals of the color blossom into its three major components: primary colors (red, yellow, blue), secondary colors (green, purple, orange) and tertiary colors (the other six petals).

Primary Colors
These colors cannot be formed by any other combination of colors, yet all other colors are derived from these three hues. If you only have enough money in your budget for a few tubes of paint, these are the colors you want.

Secondary Colors
These are created by mixing the primary colors together. This combo of colors is one of my personal favorites. Fresh and energetic—they remind me of springtime.

Tertiary Colors
The colors in between primary and secondary are tertiary colors:

yellow-orange, red-orange, red-purple, blue-purple, blue-green and yellow-green. These pretty colors are formed by mixing a primary and a secondary color together.

Complementary Colors
These are colors that are directly opposite each other on the color wheel. The arrows are pointing to sets of complementaries. These pairs of color create the strongest visual contrast which reinforces their intensity and beauty. They're a great tool to use in your art to m ake it as eye-catching as possible.

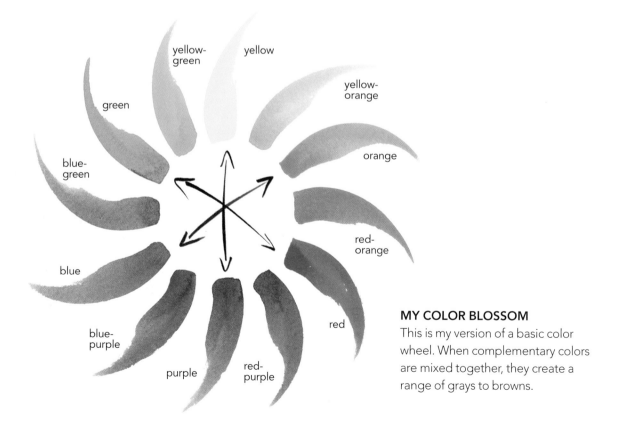

MY COLOR BLOSSOM
This is my version of a basic color wheel. When complementary colors are mixed together, they create a range of grays to browns.

Color Mixing

Now that we've talked color theory a bit, we need to actually learn how to mix colors on the palette. Since I normally work in light washes, we're going to use this as a baseline for my instruction. You can adjust the thickness or viscosity of your paints as you desire.

I use a large no. 8 round to work quickly and evenly. This disperses and mixes the paint most efficiently on the palette. You'll want to work from light to dark, so if you're mixing yellow and blue to create green, start with yellow first. It's easier to darken a light color than it is to lighten a dark color.

Wet a no. 8 in clean water to saturate the bristles and then blot it lightly on a paper towel. Dip the tip a millimeter or so into your base color of yellow. A drop of paint goes a long way. Swirl that into an empty well of your mixing palette, creating a really smooth layer of color, then add more water from your brush or spray bottle until you get your desired consistency.

Rinse the brush in water and then dip the tip into your blue paint. Start with just a small drop of paint; you can always add more as needed. Mix the blue into the yellow, making sure to reach every corner of the palette well so the color is consistent throughout. Add more water as necessary and then test a stroke on scrap paper. Is it not quite the shade of green you were looking for? Then rinse your brush off again, dip the tip into your blue paint and mix it into the yellow. You can repeat this step as many times as needed until you create the green you desire. After some trial and error, the amount of color you pick up on your brush will become second nature!

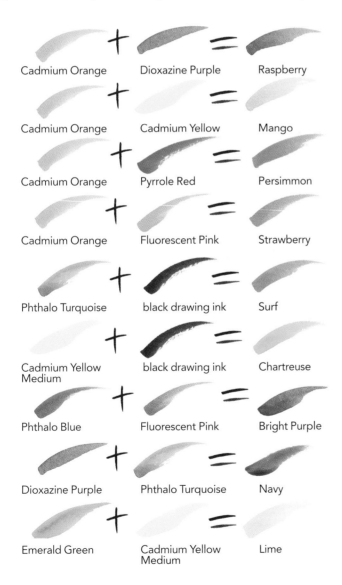

Cadmium Orange + Dioxazine Purple = Raspberry

Cadmium Orange + Cadmium Yellow = Mango

Cadmium Orange + Pyrrole Red = Persimmon

Cadmium Orange + Fluorescent Pink = Strawberry

Phthalo Turquoise + black drawing ink = Surf

Cadmium Yellow Medium + black drawing ink = Chartreuse

Phthalo Blue + Fluorescent Pink = Bright Purple

Dioxazine Purple + Phthalo Turquoise = Navy

Emerald Green + Cadmium Yellow Medium = Lime

MY FAVORITE COLOR COMBOS

Every person is naturally attracted to certain color combinations. Colors are quite powerful and can make you feel happy, calm, sad, strong, introspective, wild and a whole range of other emotions. Here are some of my favorites that energize me and make my illustrations lively and fun. Working with primary and secondary colors will become second nature to you after some practice. Try to make notes to re-create colors you like. Think of it as a mathematical equation: This plus This equals That. With the addition of Titanium White and black ink, you'll start creating your own favorites and signature colors in your paintings.

Visit artistsnetwork.com/fashionart to download free video demonstrations by Jennifer Lilya.

15

Color Mixing for Eyes, Lips and Hair

Mixing will become intuitive the more you practice. You will learn what works and what doesn't. For instance, the way to deepen yellow is by adding browns or oranges because you will find if you use black, it will turn into chartreuse. While chartreuse is a gorgeous color on its own, for fresh yellows, avoid that mistake. Make notes on scrap paper of your favorite mixtures and of failed mixes you wish to avoid.

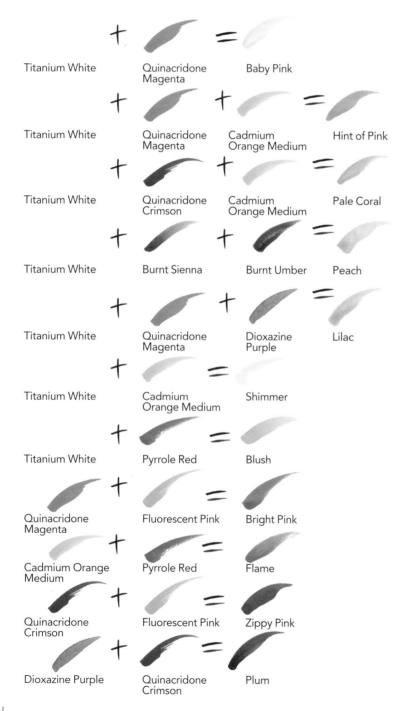

Titanium White + Quinacridone Magenta = Baby Pink

Titanium White + Quinacridone Magenta + Cadmium Orange Medium = Hint of Pink

Titanium White + Quinacridone Crimson + Cadmium Orange Medium = Pale Coral

Titanium White + Burnt Sienna + Burnt Umber = Peach

Titanium White + Quinacridone Magenta + Dioxazine Purple = Lilac

Titanium White + Cadmium Orange Medium = Shimmer

Titanium White + Pyrrole Red = Blush

Quinacridone Magenta + Fluorescent Pink = Bright Pink

Cadmium Orange Medium + Pyrrole Red = Flame

Quinacridone Crimson + Fluorescent Pink = Zippy Pink

Dioxazine Purple + Quinacridone Crimson = Plum

LIP COLOR COMBOS

Happy Girls = Happy Smiles! For fun and pretty smiles, use clean and bright pinks and reds with the addition of oranges and purples. My girls that have a sweeter and romantic look tend to wear a lighter shade of lip color. Start with a base of white and mix a drop or two of color into that, creating the creamy look that lipstick has in reality. To create a subtle shine, leave a white space on the bottom lip where light naturally falls. Then thin out your lip color with water, and paint one layer of color over the white space. This will create a muted highlight, perfect for a soft and feminine look. Using the equations here, mix up your own kissable combinations.

For more passionate and fun faces, reach for bright reds and pinks, combining them with less water for a more concentrated color. These combos are vibrant and jump off the page, making your girl appear active and energized. To create that super shiny look, leave a white space on the bottom lip to create a contrasting highlight. Mwah!

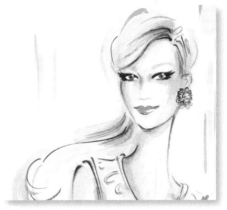

Prussian Blue	+ black drawing ink	= Eyeliner
Cobalt Blue	+ black drawing ink	= Brilliant Blue
Phthalo Turquoise	+ black drawing ink	= Wave
Emerald Green	+ black drawing ink	= Earthy Green Mountain
Emerald Green	+ Burnt Umber	= Kale
Burnt Umber	+ black drawing ink	= Rich Earth
Dioxazine Purple	+ Burnt Umber	= Fig
Cadmium Orange Medium	+ Dioxazine Purple	= Raisin
Burnt Sienna	+ black drawing ink	= Deep Copper

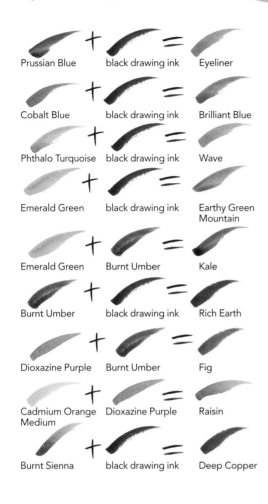

EYE COLOR COMBOS

This is a guideline of believable shades used for eye color as well as eye shadow, liner and mascara. These are the combinations I use on a regular basis for day or night looks. Any of these colors can be lightened by adding more water or Titanium White, or deepened by adding black or browns.

Titanium White	+ Cadmium Yellow Medium	= Platinum
Titanium White	+ Cadmium Yellow Medium	+ Burnt Umber = Honey
Titanium White	+ Cadmium Orange Medium	+ Burnt Sienna = Ginger
Burnt Sienna	+ Pyrrole Red	= Auburn
Burnt Sienna	+ Burnt Umber	= Brown
Burnt Umber	+ black drawing ink	= Brunette
Quinacridone Crimson	+ black drawing ink	= Warm Black
Prussian Blue	+ black drawing ink	= Cool Black

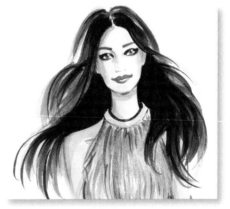

HAIR COLOR COMBOS

Hair color is naturally anywhere from the lightest white or platinum to the deepest shades of brown and black, all with a rainbow of colors in between. Here I'm focusing on natural hair color combos. For a trendy dyed look, choose any bright color straight from the tube or mix up some fluorescents for an extra kick.

Any of these colors can be lightened by adding more water for a translucent look or white for a lighter shade with an opaque look. The way to deepen any color mix containing yellow is by adding browns or purples. You don't want to reach for black since yellow and black mixed together creates a chartreuse hue, definitely not the look you're going for on a natural head of hair.

Visit artistsnetwork.com/fashionart to download free video demonstrations by Jennifer Lilya.

Color Drop Effect

Color drops are a really fun technique for creating batik effects. They're also useful for creating washy, watery patterns that can evoke a seascape, or even a floral scene from afar. They can even evoke a leopard or animal print when using those particular color schemes or patterns as guidelines.

BURNT SIENNA WITH CADMIUM ORANGE

DROPS OF BLACK INK

VIVID LIME GREEN WITH PHTHALO TURQUOISE

DROPS OF QUINACRIDONE MAGENTA

PRUSSIAN AND PHTHALO BLUE

DROPS OF CADMIUM YELLOW

Color Drop Exercise (Blue/Yellow)

The following steps apply to the Prussian and Phthalo Blue example directly above, but you can experiment with any colors you like.

1 Create a Color Swatch

Take a large brush and wet your paper in a desired shape. While the paper is wet, drop in a wash of Phthalo Blue that covers most of the wet area. The color should bleed and blend into the water, creating a soft look that stops at the edges of your painted design. Move the paper back and forth so the color and water mix together nicely. While the Phthalo Blue design is still wet, let one single drop of Prussian Blue fall into the design. Continue this with as many single drops as you like. Let dry.

2 Add Some Color Drops

Fill your paintbrush with water and glide some yellow on top of the blue pattern. You can stay within the lines, or paint outside as I did here. Once that is complete, start dropping yellow paint into the wetness. You'll see how the yellow creates a contrast layer while also following some of the paint shapes that are already on the paper. You can stop here or continue these steps with other colors until you get the look you want. It's a fun little technique that always creates a surprising and unique texture.

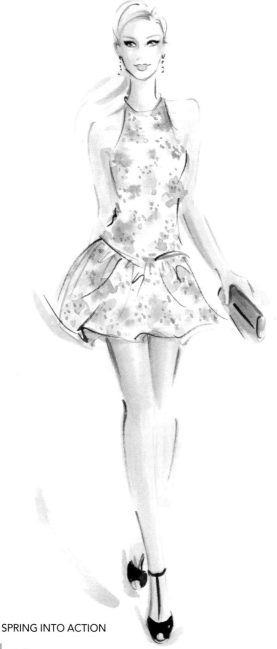

Plaid and Fur

The color drop and splatter techniques are a great way to build unique textures such as plaid and fur. Such textures have character and movement—perfect for using on garment illustrations.

SIMPLE BRUSH TECHNIQUES FOR TEXTURE

Color Wash

Concentrated Color

Dry Brush

1

Plaid Drop Base
Drench your brush in water. Here I used a no. 4, but use whatever fits the space you're working in. Brush in horizontal and vertical strokes on your paper, making sure to saturate the paper. Be as carefree or precise as the plaid pattern you want to achieve. This one has a carefree feeling—it would work well as a pattern on a flannel shirt or bouncy skirt. Add in drops of paint (Pyrrole Red) that will bleed into the water to form a crosshatch pattern. Let dry completely before applying the next color.

2

Plaid Drop Accent
Take a smaller brush drenched in water and paint thinner lines in the white space between the red design. Choose an accent color for your plaid (Prussian Blue) and drop the color into the wet design. See how easy it is to create plaids that don't take forever to paint? You can repeat these steps with as many colors as you like.

1

Splatter Base Color
The splatter effect is something we've all done as kids, and it's just as much fun now as it was then. Mix a tablespoon or two (15–30ml) of your favorite color wash (Phthalo Turquoise here) and find an old medium-sized brush or old toothbrush. You're looking for brushes with stiff, brittle bristles to propel the paint. With your paper in front of you on your drawing table, dip your brush into the color wash, and flick your finger across the tip of the brush so the paint sprays and splats onto the paper. The more paint on your brush, the more splatter but also the likelihood of more color drops like you see here. Less paint will result in a finer spray and less paper coverage.

2

Splatter Accent Color
Splatter effect dries rather quickly, so you can prepare your next color washes immediately and repeat step one as many times as you like. I used Cadmium Yellow and Vivid Lime Green to complement the Phthalo Turquoise splatter. This effect is great for mimicking the texture of fur (real or faux), sequins or tweeds. If you're doing a splatter effect on an illustrated garment, be sure to cover the rest of the illustration with paper or paper towels so the splatter covers only the area you want it to.

DEMONSTRATION
Painting Highlights and Shadows

Highlights and shadows can make or break any illustration. From a realistic portrait to a fashion illustration to an animated character, when the painted light and shadows are off, they can ruin a perfectly fine piece of art. Determining the light source on your subject is the key to any good painting. When you know where light is coming from, you know where shadows will land. If there is light shining on the right side of a face, the left side will be shaded. For most of my illustrations, I shade my girls on the left side, mainly because I work from right to left and it results in less smudging of the paint.

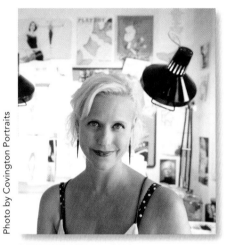

Photo by Covington Portraits

REFERENCE PHOTO
I chose this photo of me in my brightly lit Brooklyn studio as an example to paint because the light source is clearly coming from the right, and my face is shaded on the left, which is how I typically shade my girls. The photographer perfectly captured the soft bright light of my studio.

1

Underpainting and Ink Sketch
Paint the outline using a medium brush and Cadmium Orange wash. Use a 000 brush and black ink wash to sketch the details. Pay attention to how the shapes interact with each other, sketching in the facial features, hair, upper body and background shapes.

2

Color And Ink
Add in more layers of color wash for the skin tones, noting where the light source is. The white of the paper should do all the work creating the highlights in the face and upper body. Detail the eyes and mouth, and balance the figure with the earrings and straps of the shirt.

USE YOURSELF AS REFERENCE

On many occasions, an artist will have to use themselves as a model. If you don't have access to a model or can't find the right photo reference, it's easy, fun and practical to put yourself behind the camera in a pose that you need. I can't count the number of times I've used photo reference of my hands in different positions or posed in the mirror for a photo that captured the reference I required.

20

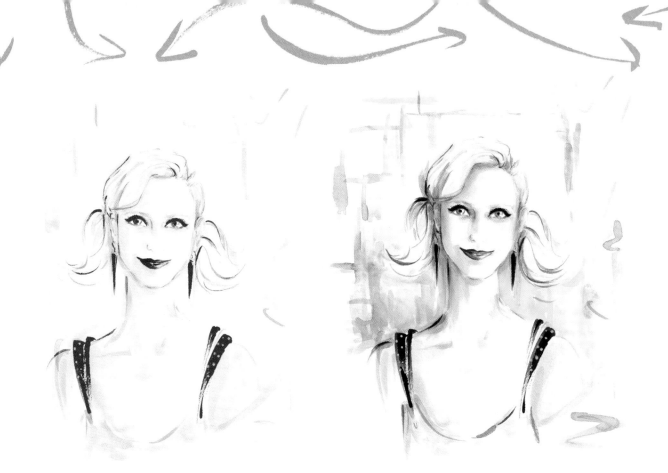

3

Detailing

More layers of color and darker ink lines help define the facial features and overall look of the image. The deeper the colors, the more the highlights become apparent and intriguing. They impart a liveliness that is necessary for an eye-catching illustration.

4

Final Art

To finish the piece add Purple Dioxazine shadows and shapes to create the background. Shade the areas between the eyes, the left side of the face contrasting the right side highlights, the hairline and under the neck. The background shouldn't be as detailed as the figure, since the figure is the focus of this light-and-shadow illustration.

GOOD VS. BAD LIGHTING

It's always preferable to create highlights in your painting with the paper itself. While this image does have some slightly lighter and shaded areas, it looks flat because the eyes, skin tone, lips and hair are missing highlights. Shadows are also needed to convey roundness and shape.

The final image in step 4 is livelier and mimics the lighting in the reference photograph better. The lights and darks of the skin work with and against each other to create a roundness and believability to the image. The white of the paper is left clean while areas with shadows (hairline, nose, between the eyes, under the neck) are emphasized. You can see that light is emanating from the right creating shadows on the left. There's also a bit of exaggeration in these illustrations, which we will touch upon in a later chapter.

Skin Tones

It's amazing the number of skin tones that can be created from just a handful of colors. Mixes of Cadmium Orange, Cadmium Yellow, Pyrrole Red, Burnt Sienna, Burnt Umber, Dioxazine Purple and black ink are all you need to create any tone under the sun! The key to lively skin tones is not overworking your paint. Maintaining fresh, quick brushstrokes retains natural highlights, while scrubbing the paper with your brush to apply color will result in a dull and lifeless illustration. You want to layer color upon color to create depth rather than start with a rich color that you'll need to blend into the paper to create any variation.

SKIN TONES IN ACTION

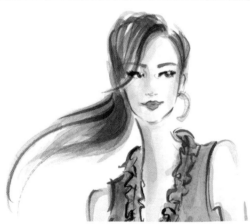

FRESH FACE

Like the good lighting example on the previous spread, this fresh face is created with just a few strokes of Cadmium Orange and Dioxazine Purple. Highlights are created with only a light wash of color over the white paper and shading is done by building up layers of color where needed.

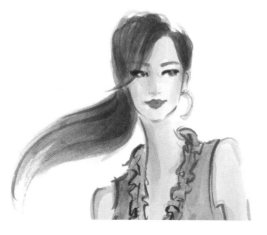

TIRED FACE

Even though the two illustrations are roughly the same, this girl looks sleepy and almost angry compared to the fresh version of herself. The color has been scrubbed into the paper, not allowing the lovely highlights and shadows to shine through. It conveys an overall flatter image, personality and all.

Full Body Skin Tone Poses

Full body poses emphasize that beauty starts at the skin and definitely runs deep! Learn how to mix a variety of skin tones on the following spread.

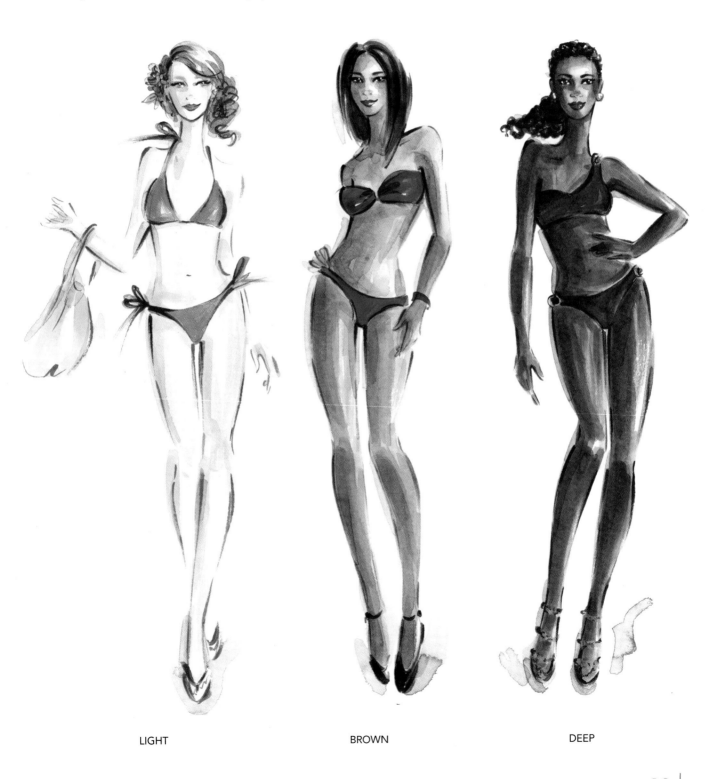

LIGHT　　　　BROWN　　　　DEEP

Visit artistsnetwork.com/fashionart to download free video demonstrations by Jennifer Lilya.

Skin Tone Color Combinations

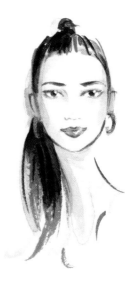

Cadmium Orange + Cadmium Yellow + Dioxazine Purple =

FAIR
Light washes of these colors evoke the porcelain qualities of fair skin.

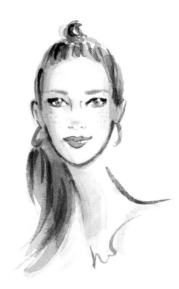

Cadmium Orange + Pyrrole Red + Dioxazine Purple =

FRECKLED
Light washes of color create the pale rosy glow typical of redheads. A few dots of color scattered upon the cheeks create cute and fun freckles.

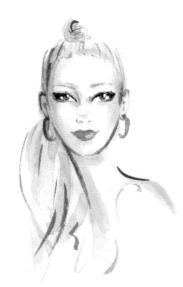

Cadmium Orange + Dioxazine Purple =

LIGHT
Light washes of color create beautiful and lively skin tones typical of natural blondes.

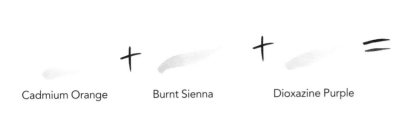

Cadmium Orange + Burnt Sienna + Dioxazine Purple =

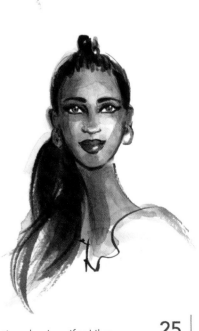

TAN
Washes of these colors create sun-kissed, seductive bronze skin.

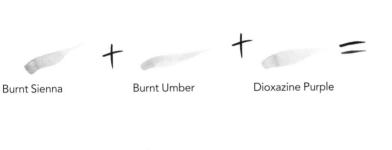

Burnt Sienna + Burnt Umber + Dioxazine Purple =

BROWN
Washes of these colors create depth of beauty in a wide range of brown skin tones.

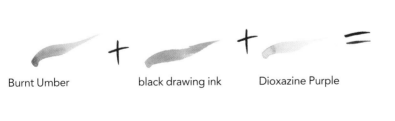

Burnt Umber + black drawing ink + Dioxazine Purple =

DEEP
Washes of these colors create a gorgeous richness only found in deep skin tones.

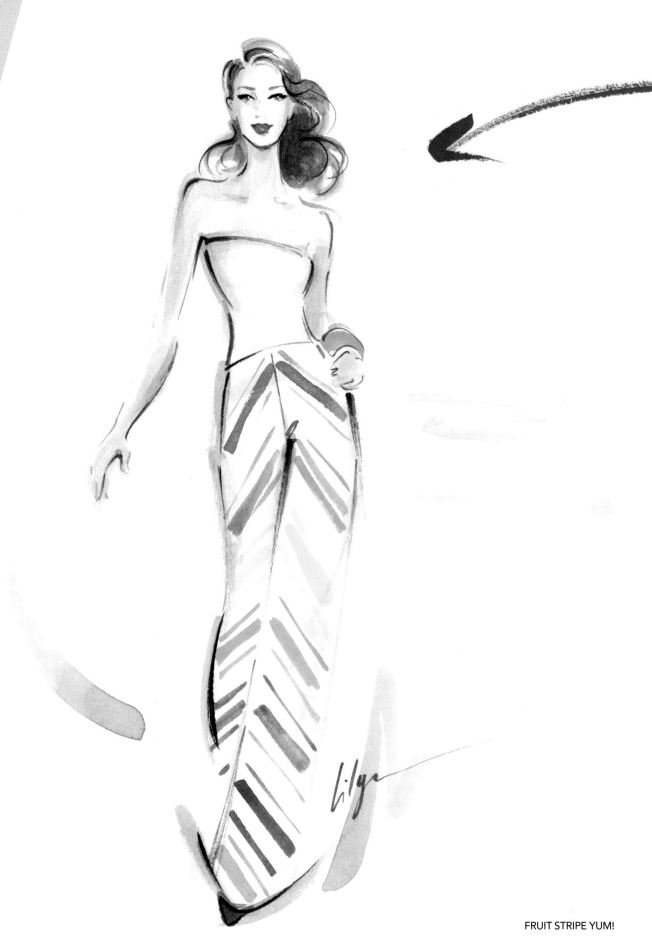

BALANCING THE FIGURE

TEALING BEAUTY

I'm a total klutz in real life—tripping over my own feet, falling into things, dropping items that I'm supposed to be holding onto—definitely living up to a bubbly blonde persona. My girls, on the other hand, are the epitome of balance and grace. Talk about trying to live through your art! It's important to find that steadiness in an illustration. You don't want your figures to look like they're falling over or dropping the accessories they're supposed to be holding and advertising in a graceful way. Part of this balance is knowing the basics of human anatomy, which I'm going to touch upon very lightly. That subject is a book in and of itself. But it's that knowledge of the underlying bone structure and muscle movement that will make your girls human, believable, gorgeous and definitely graceful.

Anatomy Basics

The basics of human anatomy are anything but. The body is one of the most complex machines, with hundreds of moving parts, positions and feelings. It's an overwhelming organism made up of complicated physical and mental states. I highly recommend doing some anatomical research on your own, especially by taking life-drawing classes. These classes are invaluable in teaching you about the body's proportions, movements and balance. The more you practice, the better your knowledge and the better your illustrations.

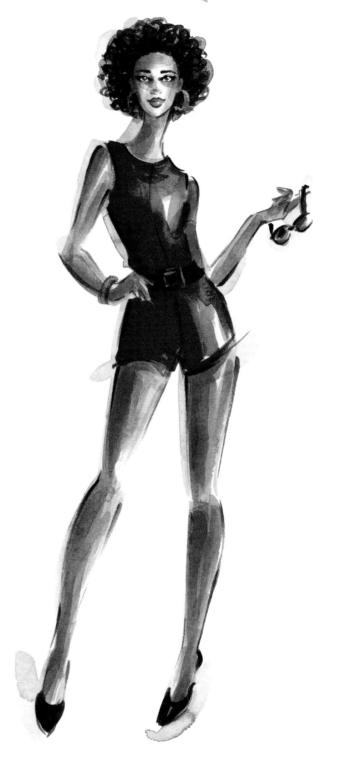

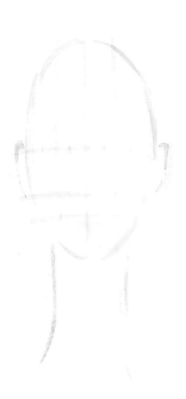

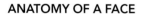

ANATOMY OF A FACE
Study the basic anatomy of a face—eyes, nose, mouth, ears, head and neck. I start all of my illustrations with a gestural sketch in a light wash of Cadmium Orange to indicate where the main features will go. Begin with a general egg/oval shape for the head. The eye line is indicated about halfway down the oval shape, and the top of the nose starts between the eyes.

BALANCING A FASHION FIGURE
Balance, proportion and movement come together when one knows the basics of human anatomy for illustration purposes. That's why even with all of her exaggerated sashaying and sass, this model is still upright, balanced and in proportion.

28

Balance a Standing Figure

Each and every one of us alternates putting the weight of our bodies on either leg or, if we're standing completely evenly, both legs at once. Take notice of how you hold yourself when you're chatting with friends, shopping, working, what have you. When you're in a casual mode, it's easy to get comfy, lean back and

put your weight on one leg. If you're in work mode, you might be standing strong and firm, weight evenly distributed on both legs. Putting your weight on a front foot might mean you're leaning in to hear a conversation, starting a walk or running a race.

It's important to notice where the weight of the body lies; this way your

figures will be in balance and not look like they're falling over on the paper. The foot carrying the most weight of the body will tend to fall in a straight line with the head of the figure. These three muses showcase proper balance in standing figures. They're illustrated in similar dark denim to highlight their leg positions.

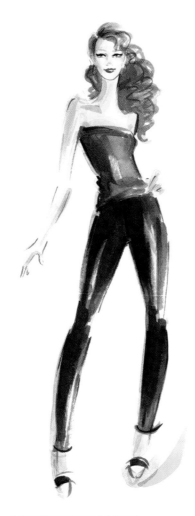

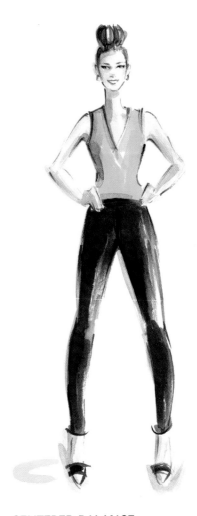

RIGHT-SIDED BALANCE
The weight of her body is on her right leg. You can tell that she's leaning back into the pose casually, with her left leg lightly balanced on her ankle.

LEFT-SIDED BALANCE
The weight of her body rests on her left leg even though there is a tiny bit of weight on her right foot.

CENTERED BALANCE
The weight of her body rests evenly on both legs. She's standing firm in a take-charge, forward-facing pose. Nobody can knock her down!

Visit artistsnetwork.com/fashionart to download free video demonstrations by Jennifer Lilya.

29

Natural Movement

Walking poses are naturally full of action and sway. Our bodies create such great shapes to paint when we pay attention to certain anatomical norms. When the body's weight is put on one leg, the corresponding hip will be higher, and the shoulder on the same side of the body will be lower. On the other side of the body, a higher shoulder will result in a lower hip. An easy way to remember this is by imagining the body having a small sideways letter V where the hip and shoulder are closest, and a large open sideways V where the hip and shoulder are farthest apart.

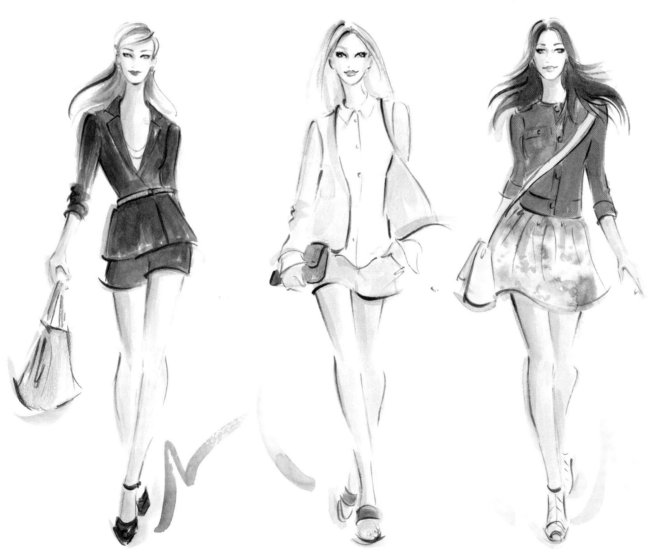

NAVY COOL
The weight of her body rests on her left leg even though there is a tiny bit of weight on her right foot. You can tell by how her pose is sunk into her hip that that's where her weight lies, but she's also ready to move on a second's notice.

PALE BLAZER
Her right shoulder is low and her right hip is high. In contrast, her left shoulder is high and her left hip is low. Blazing fashion trails wherever she goes!

SUNDAY STROLLIN'
Her right shoulder is low and her right hip is high (small sideways V). In contrast, her left shoulder is high and her left hip is low (large open sideways V). Strollin' is all about balance in movement.

Front-Facing View

Front-facing views are the most common fashion pose. Everybody wants to see how the garment looks on the model, from designers, buyers and merchandisers to advertising teams and, of course, the customers. It's our job as illustrators to make these poses as interesting as possible so the garment sells as well as our illustrations!

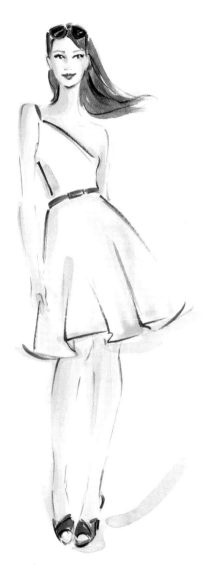

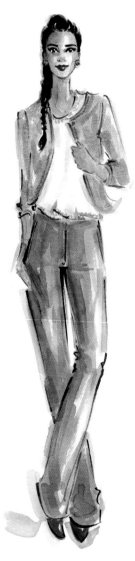

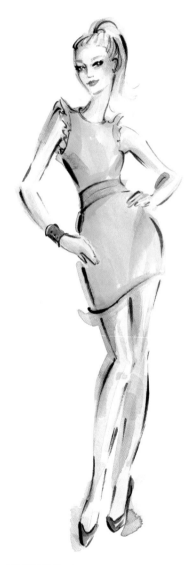

BLUE BELLE
What makes this front pose interesting is how she's holding her skirt on a breezy day and her inward-facing legs suggest a bit of coyness. *Belle du jour*, for sure!

GOLD COASTIN'
Easy luxury is eye-catching and even a little intimidating. It makes you want to meet this woman who knows how to pair expensive designer pieces with laid-back silhouettes for chic gold coastin' style.

LIMEADE
Eye contact and flirty legs are all this gal needs to make you pay attention to her sweet-tart dress. Delicious and refreshing!

Visit artistsnetwork.com/fashionart to download free video demonstrations by Jennifer Lilya.

31

Side and Three-Quarter View

Side and three-quarter views are flirty, fun and fantastic. The viewer can still see most of the garment, but side views can offer even more detail and movement since the legs are often in motion. Side views are great to use when you have more than one model per page or illustration. They create interesting compositions and interactions with other models.

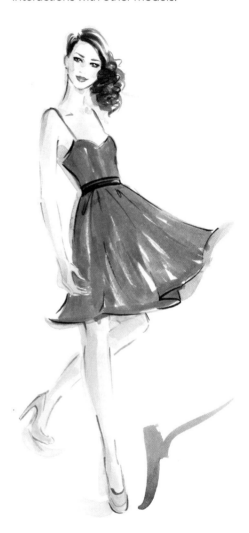
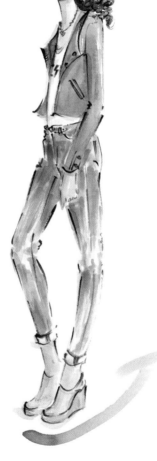
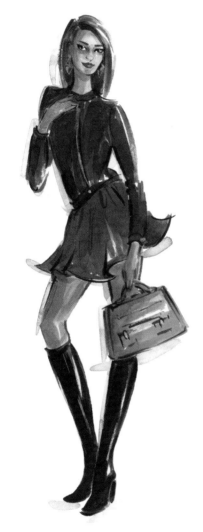

SHE BREEZE
This gal is having so much fun dancing around in this dress, it immediately makes the viewer want to purchase it and start having as much fun as she is.

COOL TURQ
You know she's way-ay cool! Our gal ups the denim and tee look with a crisp, bright leather moto jacket. Super casual gets a burst of energy from color and attitude.

FLIRT THE ISSUE
A flirty, flouncy skirt is emphasized by the back and forth movement of the model's legs. Walk this way and let's go shopping!

Back-Facing View

Views from the back are used mainly to emphasize the detailing of clothing or a hairstyle. Think gorgeous gowns, brilliant braids or designer denim. They also have an air of mystery. You may not see the model's full face, so it's intrigue at its best.

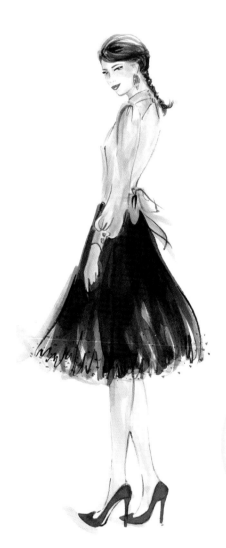
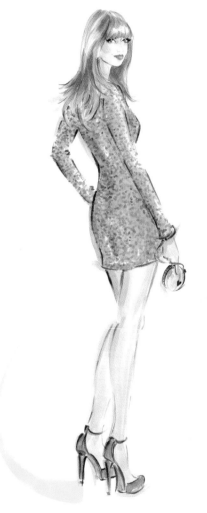
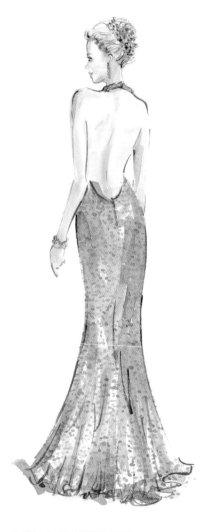

LILAC TIME
When you see Lilac from the front, you would think she's wearing a pretty conservative look—classic blouse, flouncy skirt, braided hair. But when you catch a glimpse from behind, you discover a gorgeous cutout revealing the arch of her back, a large sassy bow and sky-high heels. Fashion surprise!

EMERALD PRETTY
Follow the yellow brick road to fabulousness! Emerald is confident and gorgeous. She knows how to pose to show off her curves in a form-fitting crystal dress. The dress is full coverage, which is great contrast to the mini-length, highlighting her long legs and wild shoes.

SUCH A CLASSIC GIRL
Pretty in pink elegance! This woman is a classic beauty—updo with flowers, soft romantic curls and a dazzling dress with a gorgeous plunging back—a perfect pose.

Visit artistsnetwork.com/fashionart to download free video demonstrations by Jennifer Lilya.

33

Correcting Bad Balance and Proportion

Even slight mistakes in balance and proportion can drastically alter an illustration. Here are a few simple things to watch for and tips on how to correct them to achieve brilliant balance and proper proportion.

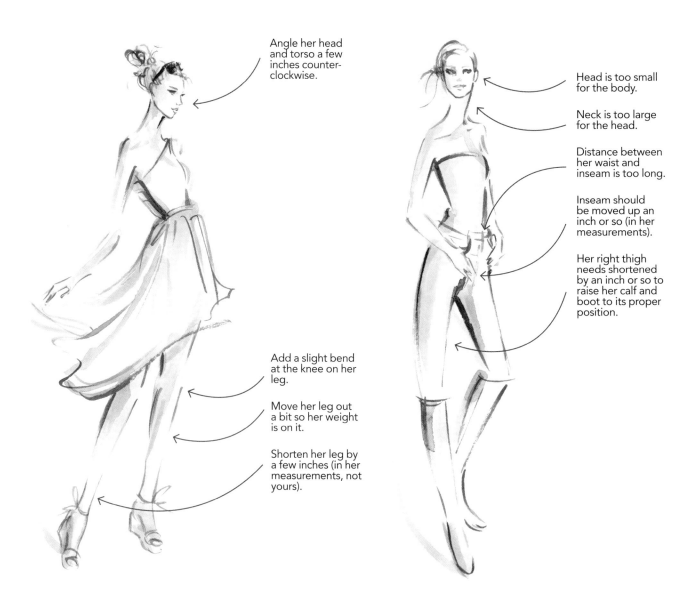

Angle her head and torso a few inches counter-clockwise.

Add a slight bend at the knee on her leg.

Move her leg out a bit so her weight is on it.

Shorten her leg by a few inches (in her measurements, not yours).

Head is too small for the body.

Neck is too large for the head.

Distance between her waist and inseam is too long.

Inseam should be moved up an inch or so (in her measurements).

Her right thigh needs shortened by an inch or so to raise her calf and boot to its proper position.

BAD BALANCE

While the model looks light on her feet, it's a little too light. She doesn't have full hold of the ground with her left foot, so it looks like a breeze could blow her right over.

POOR PROPORTION

We all love legs that go on for miles, but when the upper part of the model's body and her head look tiny in comparison, you know there's a problem.

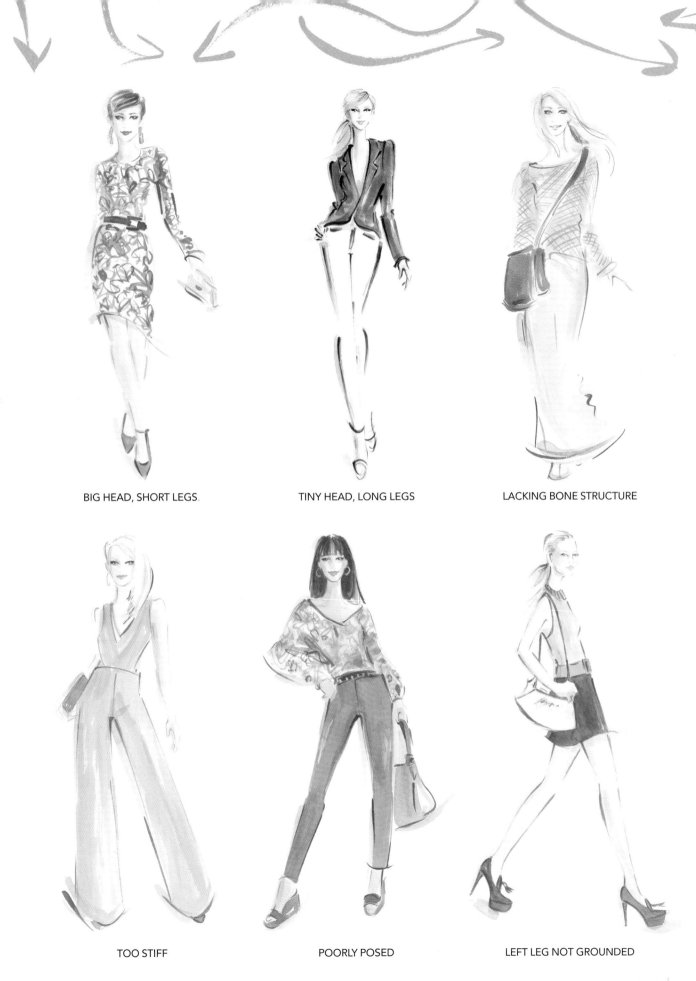

BIG HEAD, SHORT LEGS.

TINY HEAD, LONG LEGS

LACKING BONE STRUCTURE

TOO STIFF

POORLY POSED

LEFT LEG NOT GROUNDED

Visit artistsnetwork.com/fashionart to download free video demonstrations by Jennifer Lilya.

GESTURE PAINTING

WHO ME?

Gesture paintings are beautiful illustrations done so quickly and intuitively that only a few key lines of ink or color are needed to convey the shape, pose and attitude of the model. Gestures are perfect warm-up exercises to get your hand and mind used to painting what you see when you see it. Practice on your own with photo references or preferably in an art class with a live model. Gestures should be done in under a minute but ideally even less than that. I'm sure you're thinking *Huh?!?* just like I did in my first live drawing class. But once you do it, you'll fall in love with how fast your forms, attitudes and anatomies take shape.

Action Lines

Action lines are imaginary lines that follow the spinal column of a model from head to toe. When painting gestures you want to capture the essence of your image in just a brushstroke or two, and the action line is the way to achieve that. Follow your model's head and neck, curve your painted line in a way that follows the spine down to the hips, then find the leg where the body weight rests and continue your line to the toe. Once you have the main action down, you can paint in the other leg and arms.

DRAWING AN ACTION LINE
An action overlay will help you follow the spine and find the way to direct your paintbrush over the model. It's an invaluable tool to showcase the movement of your subject. Practice with a permanent marker on top of models in magazines or on some of the templates in chapter 8. It will become second nature to you in no time at all.

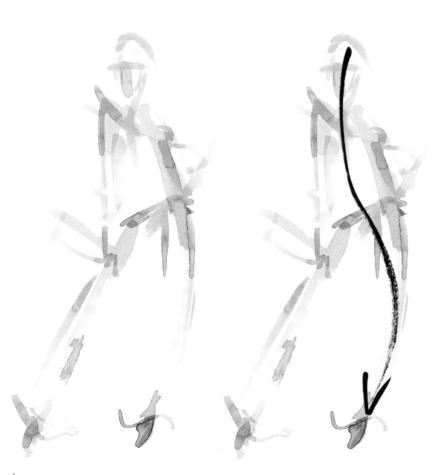

PINKY SHEER GESTURE DRAWING
This gesture was created in no time by paying attention to the action line and following that line from head to toe. It emphasizes the movement of the body, creates great attitude and captures the essence of the model in just a few quick lines. Even though the brushstrokes are quick and vague, you can still tell that the model is female because of the emphasis of her curves and that she's wearing a long-sleeved top and wide-legged pants, wearing heels and holding a clutch. Amazing what just a few lines can convey!

Here are two more examples of gesture drawings with their action line overlays accompanied by the final illustration.

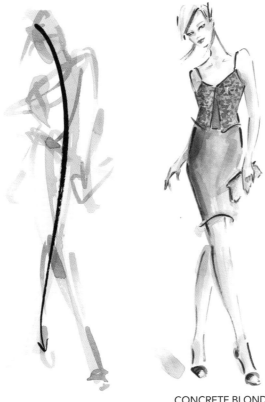

CONCRETE BLONDE

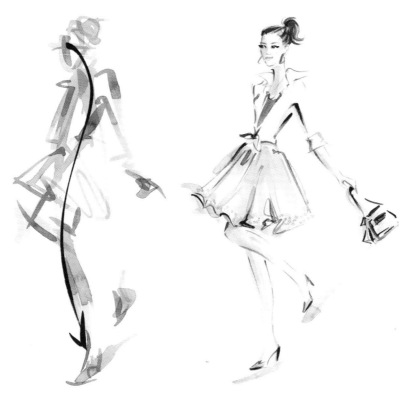

A HOP, SKIP AND SOME PUMPS

Visit artistsnetwork.com/fashionart to download free video demonstrations by Jennifer Lilya.

39

Simple Shapes

The human body is made up of shapes that interact and contrast with each other. While in reality they are complicated—soft and sharp—they can be broken down into almost kindergarten-like blocks so the viewer can see how ovals, rectangles and triangles play against each other to create movement in a painting. The more angles your figure has, the more movement and excitement your painting will contain. It makes the viewer's eye dance across the figure, discovering wonderful little nuances in painted shapes and lines.

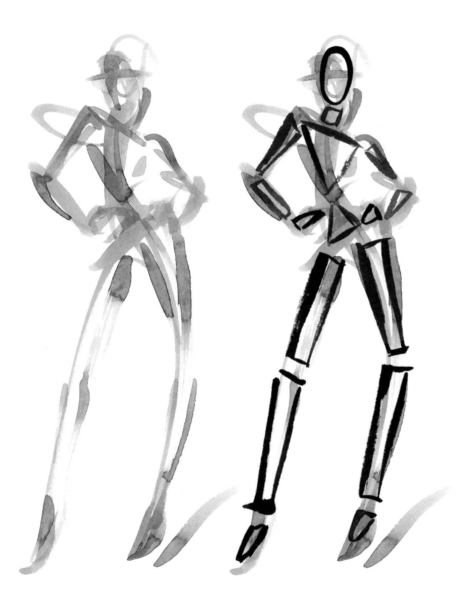

OVERLAY A GESTURE DRAWING WITH SIMPLE SHAPES

Overlaying your gesture with basic shapes helps you break down the body into different simplified parts so you can see how the shapes move with and against each other. The oval head is at a slight angle, which moves into the square of the neck, which is at an opposing angle. If you follow the action line through the spine, you'll intersect two triangles that make up the chest and pelvis areas. Follow the action line down to the legs through long rectangles and ovals for the feet. The arms are created with ovals, triangles and rectangles, mimicking the hands-on-hips pose. Move these basic shapes around to create poses that are balanced, in proportion and full of fierce movement!

The hands-on-hips pose is full of attitude and great movement. Here are two examples, each with a quick gesture, simple shapes overlay and the finished illustration.

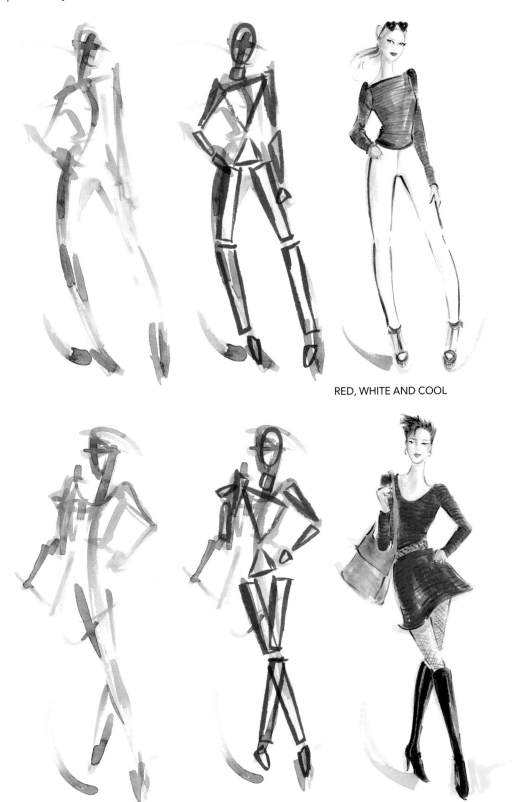

RED, WHITE AND COOL

RUBY TUESDAY

Visit artistsnetwork.com/fashionart to download free video demonstrations by Jennifer Lilya.

41

Spiral Sketches

Adding to the action line and simple shapes overlay is what I call "spiraling." Our bodies, even the tightest and fittest of us, are made up mainly of soft curves and roundness. This roundness makes your figures lively and believable, as opposed to a flat croquis or a stick-figure sketch. From head to toe, draw a spiral down the body, following the curves and different sizes of the figure. Extend the spirals out to the arms and each leg. Think of the roundness as that Slinky toy we all had as kids, slicing the illustration into round discs. This will help make your figures more real, the clothing they wear more believable and properly draped, and add more subtle movement to your art.

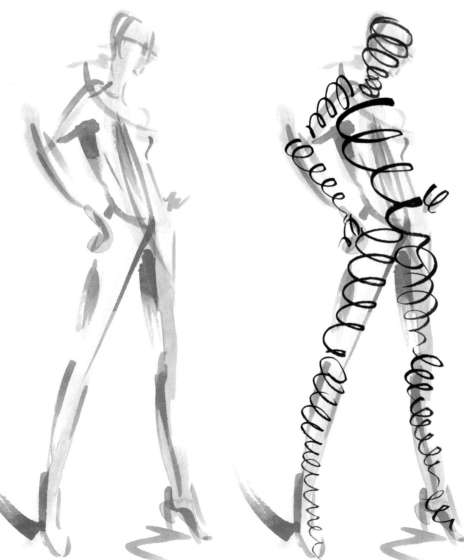

QUICK SPIRAL SKETCHES
Quick spiral sketches will help you convey roundness and believability in your illustrations. You should sketch out the spirals as quickly as you do your gestures, capturing the soft curves and movement in an instinctive, natural way. These spiral circles of life will help any illustration go from flat and blah to round and rah rah!

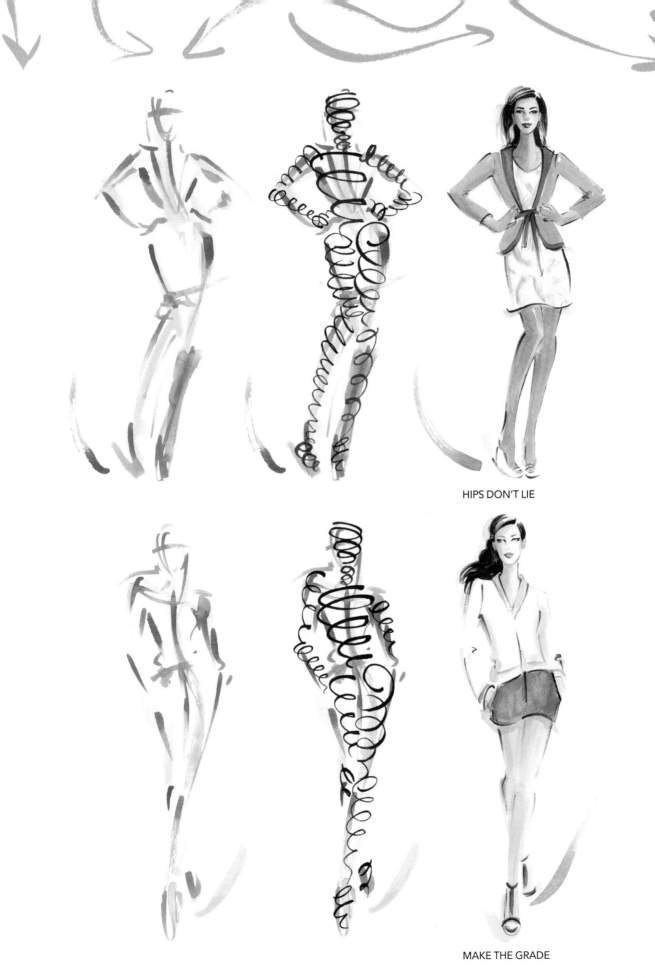

HIPS DON'T LIE

MAKE THE GRADE

Visit artistsnetwork.com/fashionart to download free video demonstrations by Jennifer Lilya.

43

Alright vs. Awesome Gestures

Gesture illustrations shown side by side really emphasize good versus bad sketch lines. Remember to work the figure as a whole while also paying attention to the different shapes that make up the body. You want the body to move together gracefully from head to toe. Keep it loose and have fun!

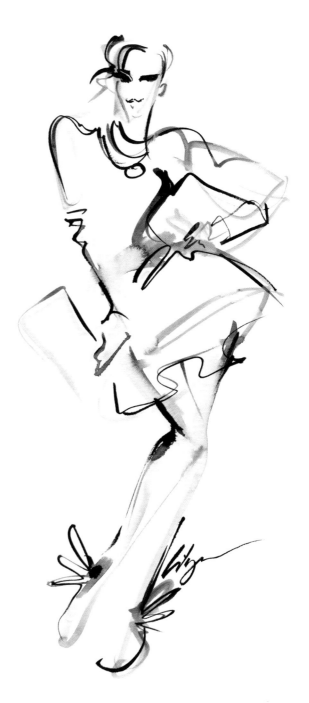

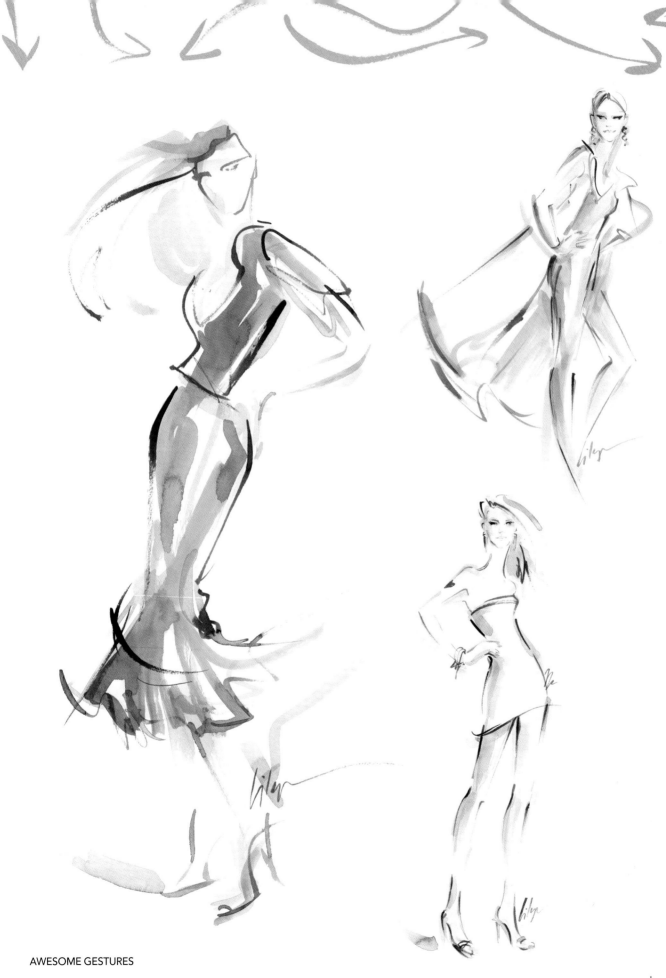

AWESOME GESTURES

Visit artistsnetwork.com/fashionart to download free video demonstrations by Jennifer Lilya.

45

Using Color Washes to Create Shapes

Color washes are layers of thinly watered-down paint that are built up on paper to create lively and energetic shapes. Use color washes to begin your drawing by lightly sketching out your image. Gradually add deeper shades of color to build out your illustration into shapes that interact and make sense as a whole. From there you can add color patterns and ink details to make your illustration come to life.

1

Underpainting and Ink Sketch
Load your brush with a Cadmium Orange color wash and quickly paint the form of your model. This should happen within ten to fifteen seconds—something quick and immediate to transfer what you're looking at (a model or photo reference) onto the paper. Let dry completely, then sketch in ink to define the areas of your illustration where you'll build up color washes. Don't focus on the details; think hair/head, torso/top, arms, legs/pants and a balanced stance.

2

Color Shapes
Mix your color washes in a small palette. Starting with the face, paint in major features—eyebrows, eyes and lips—then complete the hair color and clothes. Continue on with the rest of her outfit using Vivid Lime Green for her top, a Cobalt Blue and white blend for the jeans, and Quinacridone Magenta and white for the heels. Add another layer of Cadmium Orange skin tone.

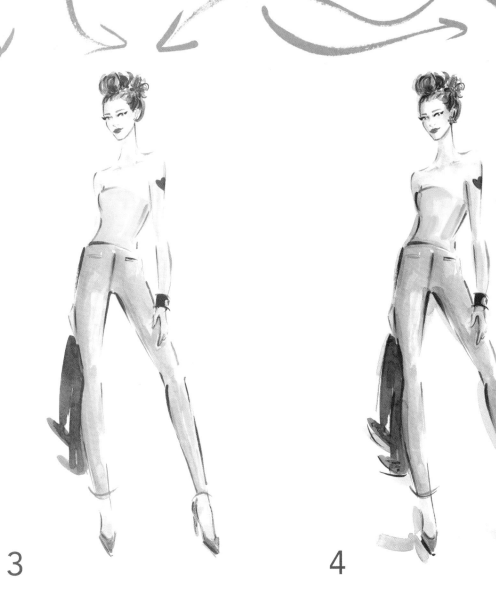

3

Detailing

Add more ink and color washes to bring your girl to life. Starting from the top with her face and hair, brush in color to emphasize her features and outlined shape. Use an eyeliner mixture (see chapter 1) for her coat and watch-band. Be aware of your brush size. For very small details, use a no. 000; for large spaces that need to be filled with color, use a no. 8. A no. 3 is good for hair, a no. 5 is good for the top and pants that you see here. You'll get the hang of which brushes to use the more you practice.

4

Final Art

Once you've reached the proper depth of color, it's time for final details of shadows and metallics to our Rockabillie girl. I used Iridescent Silver on a 000 brush to add sparkle and shine to her earrings, watch and jacket buckle. Now with a no. 5 brush, use a Dioxazine Purple wash to create shadows along your girl. Add purple shadows wherever natural shading occurs on the body: at the hairline, in between the eyes, under the arms, the sides of legs and feet, and along any creases of fabric.

LET IT DRY!

Each layer of paint needs to dry fully before you apply the next layer. This will create clean lines of ink and color versus lines that bleed into each other and colors that can become muddy. Unless otherwise noted, all painting steps in this book have been fully dried before moving on to the next step. Since so much time is spent waiting for paint to dry, I usually work on a few illustrations at once.

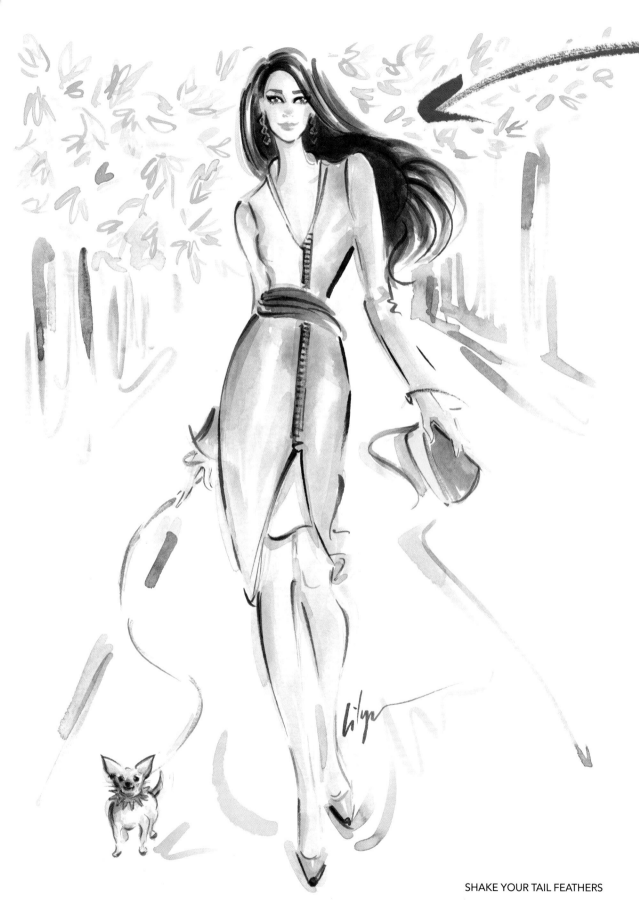

MOVEMENT & EXAGGERATION

GINGER GAIL

Fashion illustration is all about movement and exaggeration. Runway and print models are exquisite human oddities known for their rare beauty, height, grace and their ability to convey that for a client. Illustrated girls can be anything from sweet to fun to fierce, but it's all about conveying that attitude and personality. Now that you've learned to get the balance right, we can get your girls moving in the right direction.

Walking Poses

Walking poses are the ultimate in model movement. Your girls can be rocking the runway, on a city shopping spree, running to a meeting or just being cool girls on the go. Possibilities are endless. You'll notice in these illustrations that the models legs are exaggerated in full stride, hips swaying side to side, shoulders at an exaggerated angle and hair blowing in the breeze. Everyday women don't look like they're rocking the runway with imported wind blowing their hair into a perfect style, but an illustration is pure fantasy—you're selling clothing, accessories, an attitude, so all of these elements can be exaggerated to their fullest.

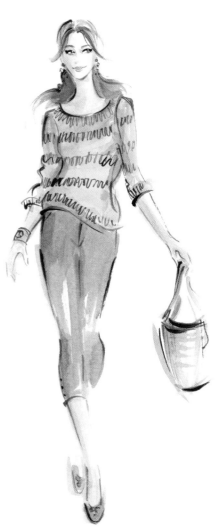

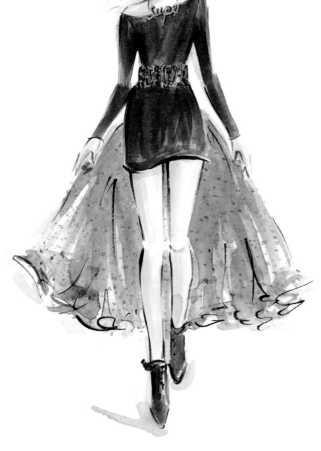

CASUAL FRIDAY

The laid-back and relaxed strolling pose is perfect to portray a girl running errands or off to meet her girlfriends for brunch. She's chill yet productive, gorgeous but not glam, pretty yet practical. Take the afternoon off and enjoy!

SUPER GIRL

This super girl is the coolest girl you've ever met. This is her daytime look for gallery hopping, dining with clients and shopping at the high-end designer boutiques. She walks straight ahead, never averting her gaze, and makes you feel as if you're the only person on the planet. Style and charm are her trademarks; her skirt doubles as a cape for days that turn into chilly nights. And as quickly as she arrives, she'll disappear in the blink of an eye.

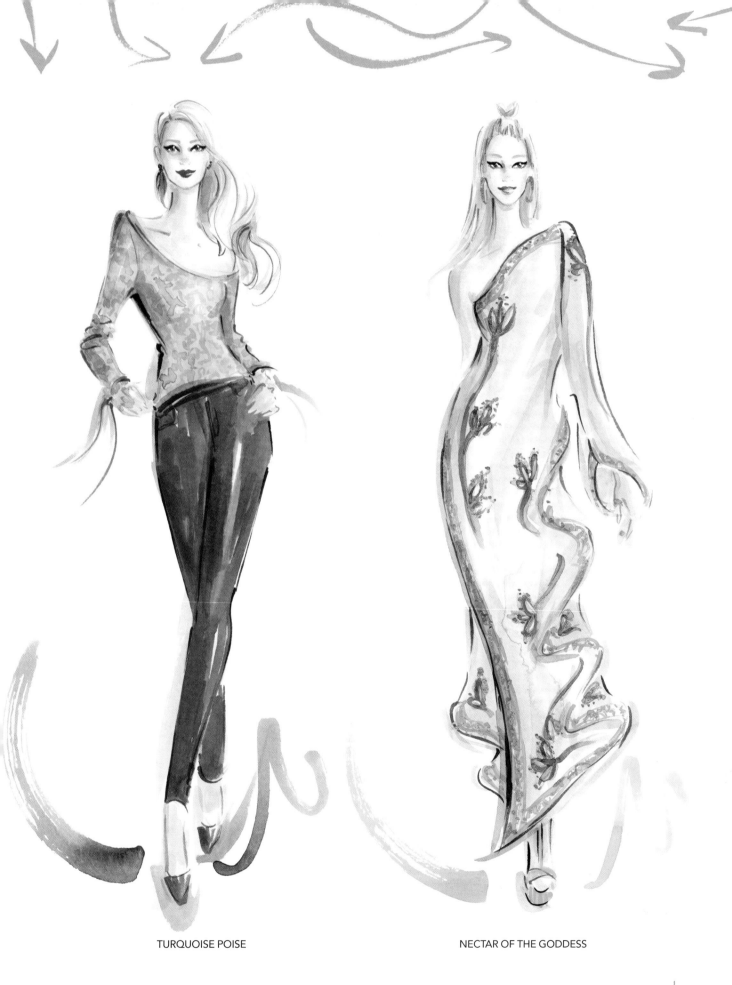

TURQUOISE POISE

NECTAR OF THE GODDESS

Visit artistsnetwork.com/fashionart to download free video demonstrations by Jennifer Lilya.

Poses With Attitude

Attitude can mean many different things, but in the fashion world, it's usually about being strong, seductive and sassy. Use these poses to visually enhance strong garments—think rockin' leathers, avant-garde or other sexy looks.

Save romantic colors and soft florals for more natural and feminine poses. In these poses with attitude, find all the tools you need to make your girls the fiercest they can be. Remember, there's strength in simplicity.

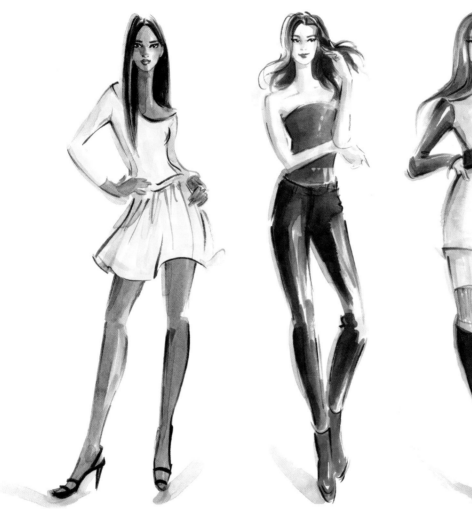
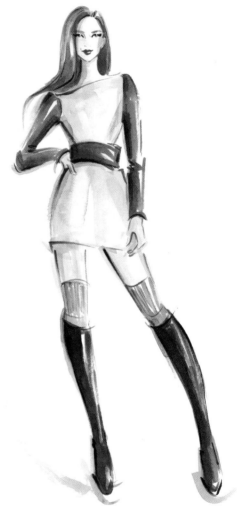

NOT SO MELLOW YELLOW

A pose such as this is all attitude. The straight-on gaze, curve of the hips and extended leg are great to sell shoes, pants or a flirty skirt. Her extended elbow is also a fantastic way to show off jewelry or even a fun, trendy manicure.

GIVE IT A TWIRL

A pose like this—subtle, sweet, a little sexy—is a nice way to sell designer denim. The model's gaze is off to the side, and the focus is on her legs while the bright top and boots frame and enhance them.

DIRTY BOOTS

The contrast between the full coverage dress and her thigh-high tights and boots is an eye-catcher. Her outfit is so cool that she doesn't even need jewelry to complement it.

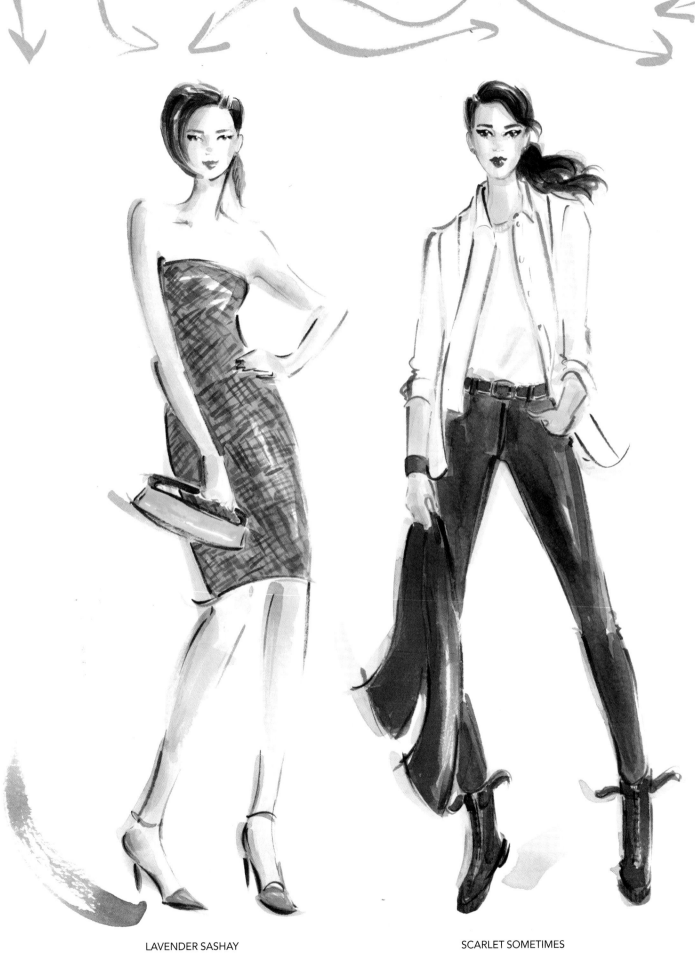

LAVENDER SASHAY

SCARLET SOMETIMES

Visit artistsnetwork.com/fashionart to download free video demonstrations by Jennifer Lilya.

53

Exaggerated Proportion

Like the models they are often drawn from, fashion illustrations are extra tall, extra thin and extra beautiful. Also like on the models, clothing tends to drape best on figures with elongated proportions, so you want to make sure your sketches reflect that. An easy tool to add to your repertoire is the "nine heads tall" rule. While an average human body is made up of seven heads from head to toe, fashion figures are elegantly stretched to nine heads. Imagine somebody pulling a figure by the top of the head, stretching out all of the proportions, making it taller and thinner. Practice these proportions after doing your gestures and finding your action line. After you complete the fashion head, take a sheet of tracing paper and make a simple oval, tracing your head's proportion.

Now take the tracing paper fashion head and move it down along your original illustration eight more times, making a light mark where the feet will land. This is the guideline you want your illustration to fit into. It might take practice to make this work for you, but your girls will eventually be the long and lean beauties they are meant to be.

EXAGGERATED: NINE HEADS TALL
This illustration is traditional fashion illustration in every sense: tall, thin, gorgeous, graceful. Her features are exaggerated and elongated. Notice the graceful way she poses her arms and legs—not something the average woman is wont to do. This gal beams beauty; her sunshine looks, trendy fashion sense and personality make her the star of the show.

AVERAGE: SEVEN HEADS TALL
This illustration shows the proportions of an attractive average-sized woman. She's slender and curvy, not stick-thin, pretty, but not drop-dead gorgeous. She's more of a fashionable figure drawing than a traditional fashion illustration. She could be your best friend, coworker or cousin.

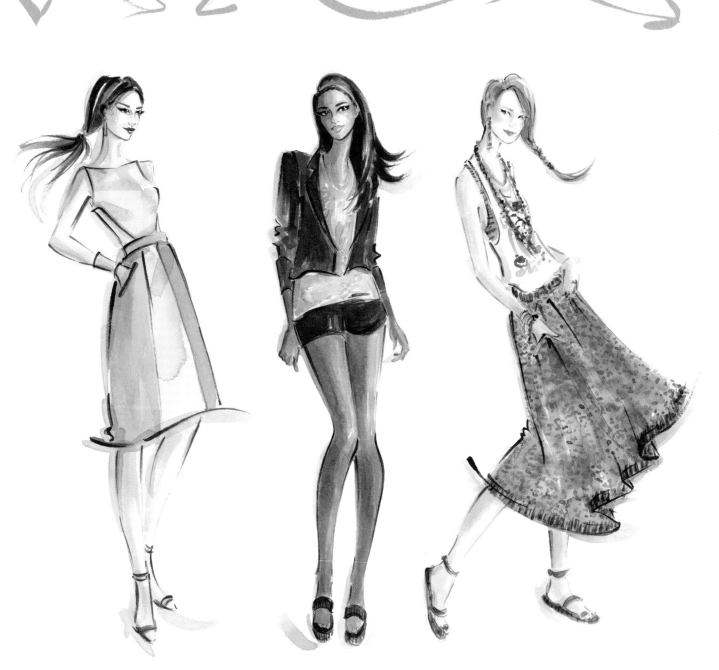

BLUES AWAY

The trendsetter is always dressed right on the mark—sleek and cool with a flash of skin at her sides. She has exaggerated features, super-long lashes, extra glossy lips and a simple ponytail turned into a high-fashion windswept style. Her gold jewelry and shoes are not flashy or ostentatious, and their simple shapes perfectly complement the lines of her dress.

LEGS GO CRAZY

This gal controls the vibe of the room with her no-nonsense, practical rocker-chic look. With her cropped black leather jacket, short shorts and legs a mile long we convey a casual cool that is always on trend. To exaggerate the movement of your figures, practice making marks with fast and determined brushstrokes.

GRATEFUL DEB

This natural beauty has everything she needs for a day at the music festival. Her flowing skirt and braid flipping outward are perfect for depicting this dancing pose. Layers of clashing patterns and accessories also create the illusion of movement. Grateful Deb gives hippie chic a whole new meaning!

Visit artistsnetwork.com/fashionart to download free video demonstrations by Jennifer Lilya.

55

Creating Movement in a Stiff Pose

Most frequently a client will request that you illustrate their garments from a straightforward angle. This of course shows off the silhouette and details of their designs. The model/illustration can be interpreted as a coat hanger advertisement to emulate how the design will hang in stores. Straightforward poses can be boring to work on and to look at, so here are a few tricks to liven up your illustration.

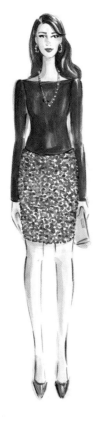

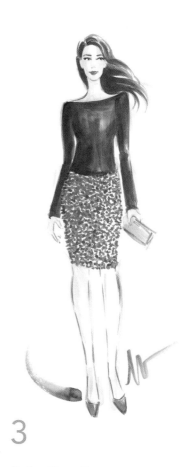

1

2

3

Stiff Pose
While cute and pretty, this gal could use some lightening up. The following steps illustrate how to make a dull pose more dynamic.

Ink Sketch
Mix an ink wash of permanent ink with a few tablespoons (30–50ml) of water. Use a 000 brush to sketch out your model from head to toe directly on top of the underpainting. Remember that a slightly angled shoulder conveys a frontward silhouette.

Color Details
Lightly paint in her major features from top to bottom. Instead of hair that's hanging down to the shoulders, pretend that your girl is in a windy environment. Her hair will be blown off to one side, creating volume and energy around her face. Place your brush at the base of her scalp and quickly make S shapes, letting the brush taper off the paper where the ends of her hair will be.

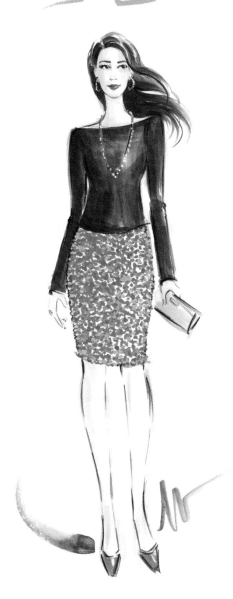

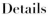

4

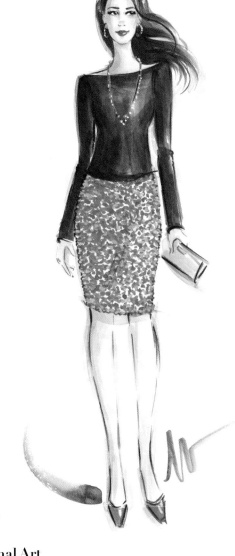

5

Details

Continue building layers of color in her skirt, top and facial details. Your model's eyes should express emotion rather than a dull stare straight ahead. Paint her irises to one side of her eye to create the impression that your girl is looking at something interesting out of your view. Add in a few longer flirty eyelashes with black ink using a quick tapering technique.

Smiles are naturally pretty, but smirks can make your girl mysterious and intriguing. Turning the ends of her lips up slightly will make her appear friendlier.

Earrings can be angled differently from each other to create contrasting light reflection patterns; necklaces can move over the body rather than hang straight off the neck. If your girl is carrying a purse, flick her wrist just slightly to move the purse on an angle. This imparts movement and is a good way to show off the front detailing of the purse.

Final Art

Almost there! Now you want to complete any dark ink details and fabric patterns. You can also use Titanium White to create stronger highlights on her jewelry. Shade the illustration with Dioxazine Purple and a no. 6 brush to give your girl more roundness and life. Focus on the light source coming from her left and create shadows on the right side of her face where darkness naturally occurs: at the hairline, the side of her nose, cheekbones, where her arms meet her torso, her waist, a shadow under the hem of her skirt and down to her shoes. For all of these shaded areas, remember to use quick and expressive strokes away from the figure. They evoke energy and action emanating off your girl rather than washes that are contained in a smaller space without much variation in paint layers. And there she is, moving forward!

Visit artistsnetwork.com/fashionart to download free video demonstrations by Jennifer Lilya.

57

Alright vs. Awesome Movement

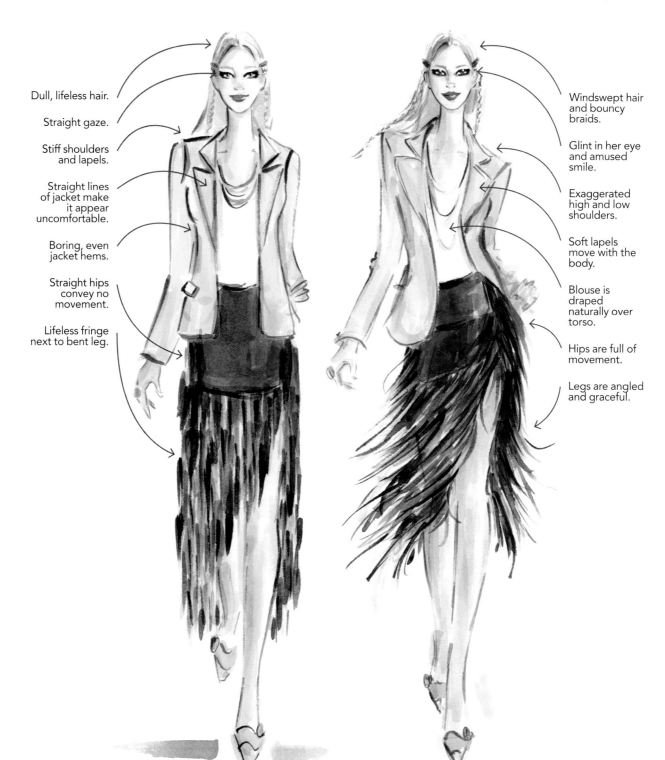

Dull, lifeless hair.

Straight gaze.

Stiff shoulders and lapels.

Straight lines of jacket make it appear uncomfortable.

Boring, even jacket hems.

Straight hips convey no movement.

Lifeless fringe next to bent leg.

Windswept hair and bouncy braids.

Glint in her eye and amused smile.

Exaggerated high and low shoulders.

Soft lapels move with the body.

Blouse is draped naturally over torso.

Hips are full of movement.

Legs are angled and graceful.

SORRY WITH A FRINGE

FRINGE BENEFITS

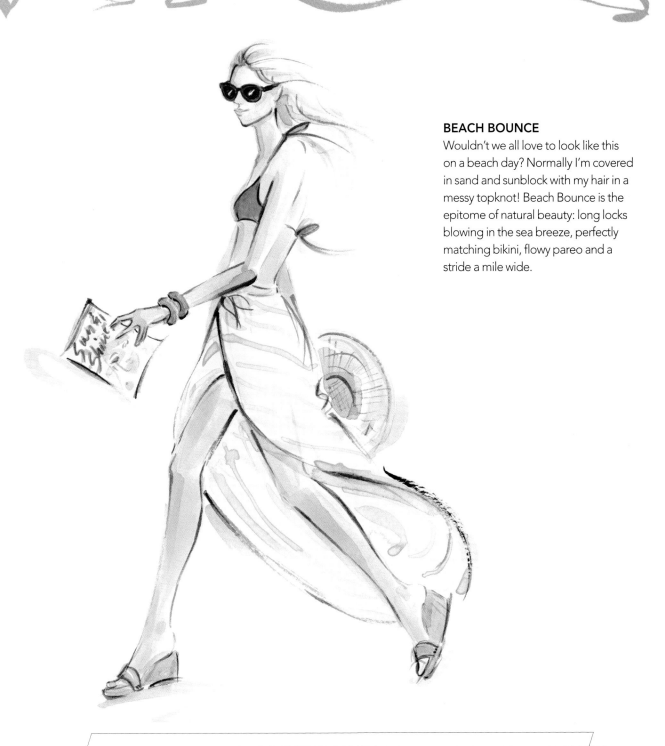

BEACH BOUNCE

Wouldn't we all love to look like this on a beach day? Normally I'm covered in sand and sunblock with my hair in a messy topknot! Beach Bounce is the epitome of natural beauty: long locks blowing in the sea breeze, perfectly matching bikini, flowy pareo and a stride a mile wide.

DON'T OVERWORK IT

If you feel like you're struggling or overworking a piece, you probably are. When this happens, take a break. Get up from your painting area for a few hours, then look at the piece later with fresh eyes. You'll be able to discern if you should continue on or start again. Never be afraid to rip it up and start again. I usually start my problematic illustrations over from scratch. I know it's a hard thing to do after putting in a lot of work, but sometimes a fresh start is all you need on a painting that can't be saved. Keep your emotions out of it. Be pragmatic about finishing your project to meet your needs or deadlines. A fresh start usually takes less time than struggling over an illustration that's already overworked or is off in some way.

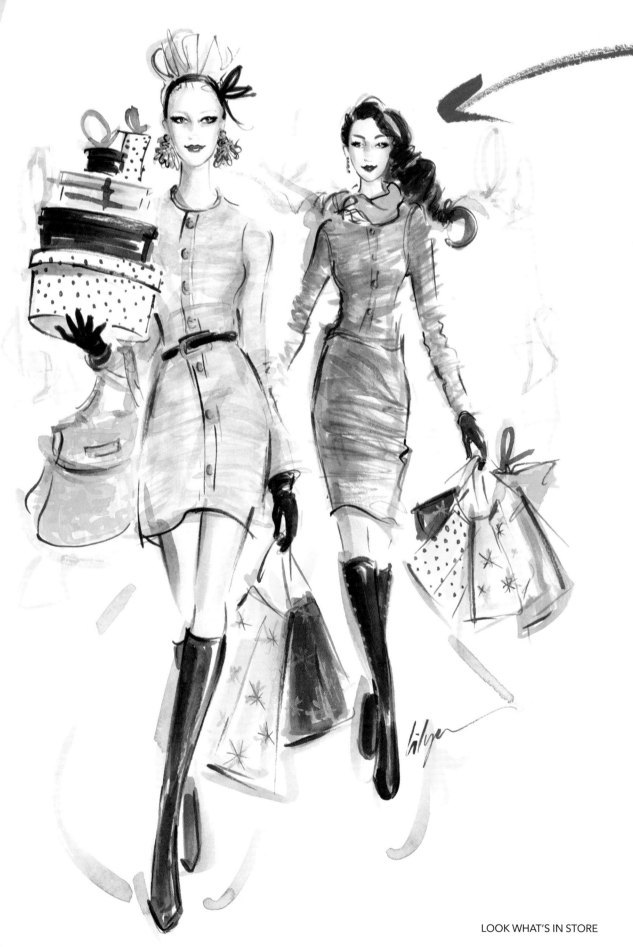

LINE QUALITY

VESTED INTEREST

Line quality is my favorite artistic concept. It can make or break any illustration! It's the difference between an okay piece of art and art that has a little more pizazz and liveliness. By definition, line quality is a set of attributes that describe a drawn or painted line: light/dark, thick/thin, wavy/straight, slow/quick, smooth/textured, short/long, etc. Lines with variation create more visual interest than lines without. I'm sure you've noticed good or bad line quality without even realizing it. An illustration may look good enough, but if its lines are all uniform in weight and size, it might look like the figure is just outlined and flat rather than enhanced by lines that vary in weight and texture. It's always the small details that bring your girls to life and make your art stand out among others.

Brushstroke Basics

Beautiful lines and brushstrokes will enhance the elegance and mood of your illustrations. A variety of brush sizes are key to any good illustration. You need an array of choices to work with. You don't want to paint delicate details of a face with a large brush, and on the other hand you don't want to paint large areas with a tiny brush. Both instances will make your girls look sloppy and overworked. You won't be able to achieve delicate and beautiful facial details with a large brush, and you'll most likely overwork the paper if you try to scrub in large areas of color with a small brush. Maintaining freshness in a fashion illustration is achieved by limiting your brushstrokes, knowing which brush sizes to use and when to stop painting altogether. If you brush up on these basics, you'll start having strokes of deliberate luck and beauty!

BRUSHSTROKE SIZES

Here you'll find the actual size brushstrokes from brushes I use every day. The first stroke is created by lightly gliding the tip of each brush along the paper, and the second stroke uses the side of the brush to create a thicker line. Make sure to add a variety of brushes to your everyday supplies. Brushes can be quite expensive, but if you stick with synthetics, some name brands and especially store brands are financially friendly. If you only have room for a few sizes in your budget, I recommend you start with two 000s (one for light paints, one for black ink), a 2, a 4 and a 6. Again, if possible, buy two of each size for lighter colors and darks. This will save you money in the long run by not having to wash brushes frequently, and it will also keep your paintings looking fresh and clean.

tip of brush	side of brush	brush numbers top to bottom:
		000
		0
		1
		2
		3
		4
		5
		6
		7
		8

LARGE GINGHAM, LARGE BRUSH

SMALL GINGHAM, SMALL BRUSH

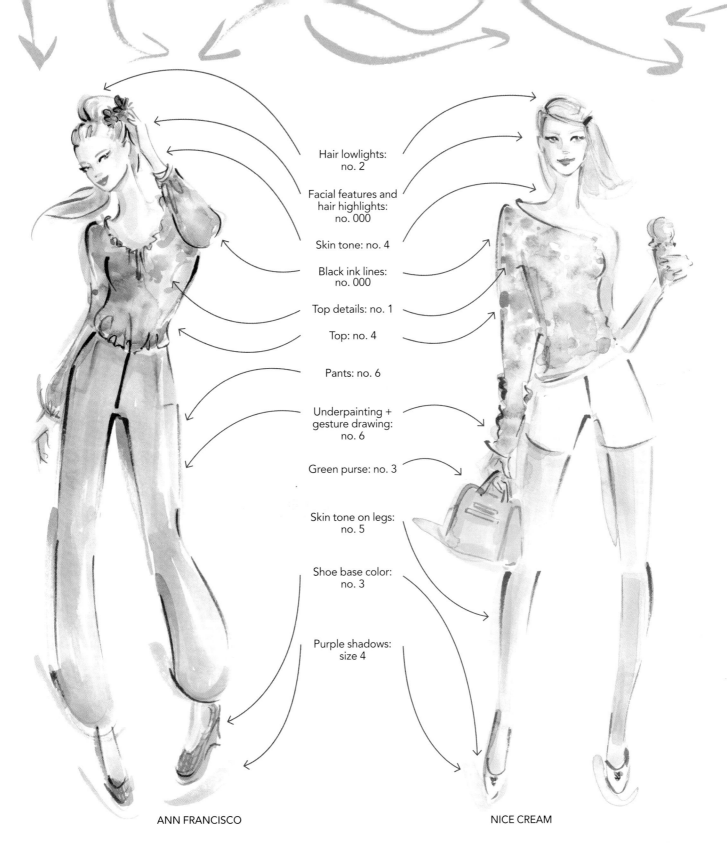

Hair lowlights: no. 2

Facial features and hair highlights: no. 000

Skin tone: no. 4

Black ink lines: no. 000

Top details: no. 1

Top: no. 4

Pants: no. 6

Underpainting + gesture drawing: no. 6

Green purse: no. 3

Skin tone on legs: no. 5

Shoe base color: no. 3

Purple shadows: size 4

ANN FRANCISCO

NICE CREAM

SELECTING THE PROPER BRUSH SIZE

Create all the movement in these two girls with just a few brush sizes! For fine details in the hair and face, you want to use your smallest brushes. For the batik effect of their blouses, a medium brush is useful, and for the bell bottoms and skin tones, a larger brush fills the space perfectly. Move back down to 000s for ink line details.

Visit artistsnetwork.com/fashionart to download free video demonstrations by Jennifer Lilya.

Brushwork Basics

Acrylics are amazing in that you can achieve such a wide range of shades just by using water and mixing well. You can create the lightest, subtlest lovely shade of color all the way to the deepest, most intense color and texture.

Mixing Opaque vs. Translucent

The amount of water needed on your brush will vary by the subject or the area you are painting. Like with the sizes of a brush, there's a huge range of opacity in acrylic paint. To mix the lightest tones, fill a well of your mixing palette with approximately a tablespoon (15ml) of water. Add one small drop of paint and mix well with a larger no. 6 brush to create a very light wash of color. Re-create these steps each time with more paint for a gradation of color washes from lightest to darkest. When you need the deepest possible saturation of color, squeeze your acrylic from the tube, wet only your brush or give the paint one spritz of water, then proceed to use the paint as is. You'll find that it's quite thick and will create bumpy layers of texture. To avoid a rough surface of paint on paper, wet your brush slightly more until the acrylic is a little more workable and smooth. You'll still have the intensity and full opacity of color, but it will be a little easier to manage elegant brushstrokes without the paint drying immediately and halting your brush midstroke. If you're looking for texture, say in a silhouette involving metallics or a heavily textured fabric, go for it! Use the acrylic paint directly from the tube in small amounts.

Blotting the Painting Surface

I use two sheets of paper towels folded into fourths, and tuck them under the edge of my palette, right above my scrap test paper. Be sure your paper towels are plain white because sometimes the color in paper towel designs will rub off on your brush and ruin a painting. Blotting on paper towels is essential when using acrylics with water; your painting will be a drippy, nondetailed mess if you don't blot your brush. I blot color in a couple different ways. With a larger brush I'll take the side of the brush and blot it like I'm starting to paint on the paper towel to absorb enough paint and water so my brushstrokes will still be rich in color but not dripping and out of control.

For smaller brushes that don't contain a lot of paint but still have just a bit too much on the delicate point, blot the side of your brush on the edge of the folded paper towel to absorb just enough paint so it

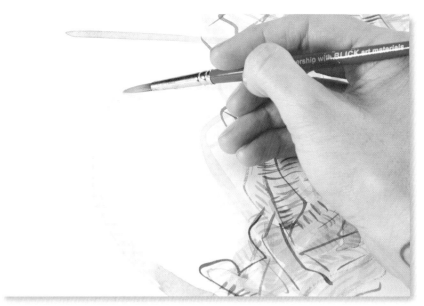

PAINTING QUICK AND LOOSE
This is how I hold my brush when painting fun and loose background swoosh marks that help give my illustrations the illusion of movement.

doesn't drip but will keep the paint concentrated perfectly on the tip of the brush for you to use in creating fine details. Who knew there was a technique to blotting? Try it out! You'll be pleasantly surprised at the difference it makes in your art.

I also use paper towels ripped in halves and quarters for blotting up accidental drips or smudges on the paper or for placing on the area of the paper where my hand lies. This saves the tooth of the paper by limiting the touch of my skin movement (and even natural skin oils or moisturizer) across the paper. You know how paper looks when it gets overworked with too many brushstrokes or erased lines: if you work a lot in one space, the side of your hand and wrist can actually rip up tiny pieces of the surface of the paper and create an unwanted texture.

Testing Your Brushstrokes

When those blotting towels become too dirty with brushstrokes or smudges, save them to clean the surface of your palettes. They're perfect to use to clean the tiny wells or large mixing area of the palette. You'll find a setup that suits you best, but having all of your supplies within reach is most desirable.

Along with your paper towels, you'll want scrap paper to test your color brushstrokes on. I prefer to use the same type and color of paper I'm actually working on so the color tests will be accurate. I use the backs of rough sketches or paintings that didn't work out so well. I save unsuccessful paintings and trim them down to a size that fits under the edge of my heavy palette and are at the same time large enough to test a good deal of brushstrokes. You don't want to have to keep replacing scrap and interrupting your painting energy.

I test each and every brushstroke of color before I put it down on my illustration. It may seem like a lot of work, but the action will become innate, take about a second to do, and it's most definitely a time-saver and painting-saver overall. You can easily correct color on your brush, but if you paint the wrong color onto your illustration, the illustration most likely won't be salvageable unless the color is light enough to blot up quickly or paint over with a darker color. Do yourself a favor and remember to always test your brushes on scrap.

HOW TO LOAD A BRUSH

These swatches illustrate how to properly load your brush with paint and water to get the desired line quality on your paper from translucent to opaque.

1. A tablespoon (15ml) of water mixed with one drop of paint (Pyrrole Red). One small drop of paint is accomplished by dipping the tip of a no. 6 into a millimeter of paint. This amount of paint would fit on the head of a pin.

2. A tablespoon (15ml) of water mixed with two small drops of paint.

3. A tablespoon (15ml) of water mixed with a no. 6 brush half filled with paint.

4. A no. 6 brush filled with paint with about a teaspoon (5ml) of water mixed or spritzed into the palette well.

5. A no. 6 brush filled with paint from the tube and just a spritz of water to keep the paint from drying on the brush midstroke.

Visit artistsnetwork.com/fashionart to download free video demonstrations by Jennifer Lilya.

67

Overworking an Illustration

Overworking an illustration is one of the biggest mistakes an artist can make, especially a fashion illustrator who relies on the freshness of color and line to convey a designer's mood and silhouette. Even if the rest of the illustration is fine, your eye (and possibly your viewer's eye) will be drawn to that mistake instantly. When this happens, your best bet is to just throw out the painting and start over. It'll take some time getting used to, but after a while you'll realize the necessity of it. Your paintings will eventually all be fresh and pleasing to the eye, and you'll find that restarting the painting has saved you time.

One common way of overworking an illustration is not knowing when to stop painting. Sometimes we become engrossed in the art, and when we finally step back to check it, we realize that all those layers of line and color have made it become dull and lifeless. Young artists (in age or practice) also tend to color in everything without leaving the white space of the paper showing to naturally create highlights and contrast. This creates an overall dullness since it's so hard to go back into the painting and lighten skin tones without it looking overworked. The skin color also becomes creamy and flat, lacking a variation in the tones that create the roundness of the face. On top of that, hair is lifeless and wig-like without great highlights, eyes are deadened, jewelry has only a faint sparkle from the metallic paints, patterns are flat and the overall ink lines become forced and sloppy.

These side-by-side examples detail all the dos and don'ts of overworking your brushwork to turn a clean, crisp image to dull and flat.

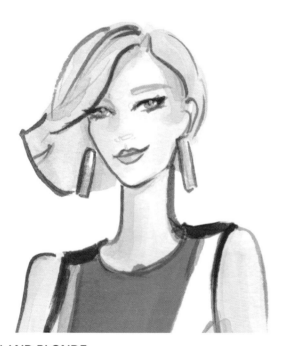

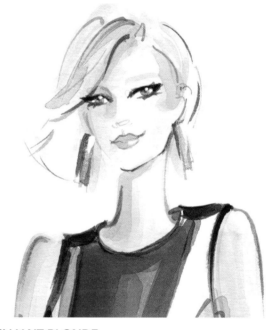

BLAND BLONDE

Too much blonde mixture on the brush makes her hair look like a pile of mustard. Her eyebrows do not need ink outlines; we want natural lightness to grace her face. Her lip shape is fine and fun, but that black outline is unnecessary and not at all subtle and pretty. Her skin almost matches her hair with very little contrast between the few shadows and skin color. These ink lines look deliberate as opposed to quick and intuitive.

BRILLIANT BLONDE

It's easy to paint blondes light and fresh. Just a few strokes of color can create her hairstyle using the white of the paper as natural highlights. Her skin tone is created in the same way—with subtle color for the bright blonde eyebrows. The difference in weight of the black ink throughout the painting creates a lovely contrast between the softness of her face and hair and the sharpness of her color-blocked dress.

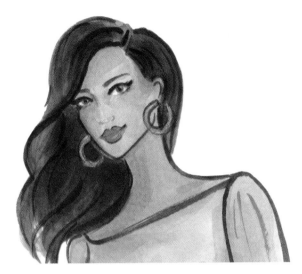

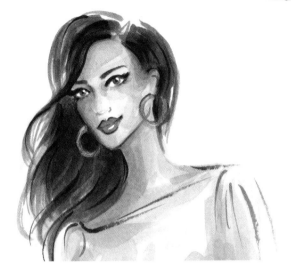

TAUPE NOPE

This version is so flat that it looks like she was ironed out and all the paints blended into each other to create almost one tone. While the shape of her hair is still nice, the lack of highlights or tapered ends makes it look like a woodland creature is sitting on her head. There's virtually no distinction between her flat skin tone and the color of her blouse.

DOPE TAUPE

This girl is superfine and fresh. Her hair looks natural with a sexy side swipe and tapered brushstrokes that create soft layers to frame her face. Her makeup is dramatic but not overly done, and her lips are gorgeously glossy. The lightness of the paper shining through her blouse creates movement and a fabric that is slightly ruched.

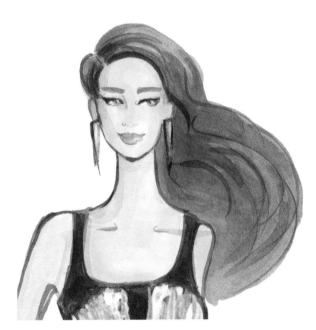

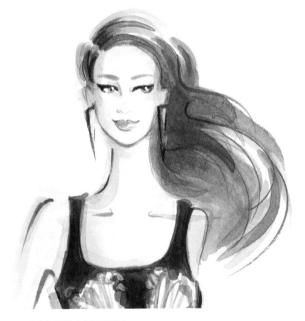

AWWW … BURNED

Awww, this poor version of Auburn is just depressing. Without highlights in her hair, it looks like a misshapen bad wig. Her skin tone is flat, and it looks as if the paint was scrubbed into the paper to blend the layers of color and shadow together. The ink lines are overall too fat and one-note, while the white on her top looks bubbled and messy, trying to achieve a real white painted over any darker color. See how overworking is a total painting killer?

AWESOME AUBURN

The difference here is striking. She's lighter in feel and her lines create quite a bit of action. Her hair is model-wild and windblown, which is created by painting quick strokes of color in varying widths, letting the white paper become brilliant highlights, and her ink lines are active and properly spaced for greatest effect. The white part of her dress was made by letting the paper show through. It's easy to go from light to dark rather then paint white over black.

Visit artistsnetwork.com/fashionart to download free video demonstrations by Jennifer Lilya.

69

Black Ink Lines

What I adore about painting with black ink is how smooth in feel and deep in color it is. I prefer using black ink over acrylic paint for this reason. To reach the desired smoothness in black acrylic would require it to be watered down so much that its color intensity would virtually disappear. It's also super easy to create textured lines with the darkest ink, and it dries relatively quickly on a brush, so creating lines with tapered texture is a breeze! Black ink can be used in the lightest gray wash imaginable to straight-out-of-the-bottle pitch black. It's perfect for doing your light underpainting ink lines and coloring the deepest, shiniest black leathers. And the shades in between can all be used for so many parts of your paintings. Give it a try and discover how amazing and easy it is to work with!

Cool hue: A few drops of black ink mixed with Prussian Blue

Black ink mixed with just enough water to create a smooth line

Warm hue: A few drops of black ink mixed with Quinacridone Crimson

ALTERING BLACK INK FOR WARMS AND COOLS

Ink can be used straight out of the bottle or mixed with paint to embody cool or warm tones. Straight black ink, while intense and gorgeous on its own, can put a visual hole into any painting. The black is so black that it can create an empty space your eye is drawn to. But adding Prussian Blue to make a cool black, or Quinacridone Crimson to make a warm black will give that black hole in your painting a different kind of energy. Here are three examples of how color infused with ink can create a livelier look. Try using blue and black for outfits or situations that contain more cool hues like blues and greens. It complements the other colors nicely without weighing them down. For outfits or scenes that contain a lot of warm colors like oranges and reds, use red and black together to complement the rest of that painting. The only time I use ink without extra color added is when I paint the black ink lines of any illustration. For that I want to create a neutral outline of all the shapes and colors, one that won't clash with any of the other colors in the art itself.

FEWER LINES = FRESHER LOOKS

You don't need to show exactly what you see—wrinkles in the clothing or on the face, fabric that's draped oddly, a model who might be shorter than you need or complicated hand positions. You want to achieve a fresh look with few lines. It's your job to "iron" the clothing and drape it naturally. Generally, fashion faces should be fresh and young (unless your subject doesn't fit into that category). You're the editor! Exaggerate height and movement and edit down the amazingly complicated lines of a hand.

Line Weight

Line quality isn't hard to quantify; a painting either has it or it doesn't. For me, an illustration that contains great line quality is a million times more interesting and eye-catching than an illustration whose lines are mostly all the same width, color and texture.

Let's use hair as an example. Even the thickest mane will still be painted in thinner textured lines than an article of clothing made from a heavy textile. For light objects and delicate details you want to paint lines that are light, lively and fun. Think of soft waves of hair blowing in the breeze and light, flowy cotton skirts—you wouldn't want to use thick, dark textured lines for objects like that. You want to use soft, subtle and energetic lines. On the flipside, you wouldn't want to use soft, sweet lines for a heavy tweed or fur; for those you want thicker, textured lines that are more angular versus flowing.

While there are endless kinds of lines in the world, I've painted a few fun ones here for you to use and expand upon in your art. Take some time to practice your line quality while paying attention to light and dark areas: soft versus strong, streamlined versus textured, etc. Once you start painting with interesting lines, there's no way you'll go back to the rigid, lifeless lines you may have once painted with.

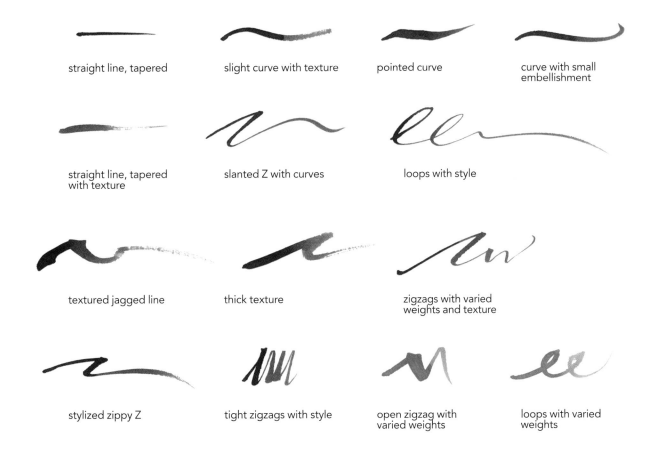

straight line, tapered

slight curve with texture

pointed curve

curve with small embellishment

straight line, tapered with texture

slanted Z with curves

loops with style

textured jagged line

thick texture

zigzags with varied weights and texture

stylized zippy Z

tight zigzags with style

open zigzag with varied weights

loops with varied weights

CONVEY EMOTIONS WITH LINES

Lines that move upward give the illusion of positivity and happiness, while lines that move downward tend to feel negative and blah. Think of how the corners of lips or eyelashes flare out to the sides then upward.

Linework and Shading

Great linework and differently weighted lines will convey shaded areas on a figure or object. Here, delicate ink lines mimic the fine qualities of Silver Slither's hair and feathery bracelets. And thicker ink lines can be seen where her body parts are naturally in shadow or touching each other. The side of Club Kitten's right thigh has a slightly darker, thicker ink line for shaded areas, and her left thigh has been depicted with slightly thinner and lighter strokes to show the viewer where the light source is coming from (our right, her left).

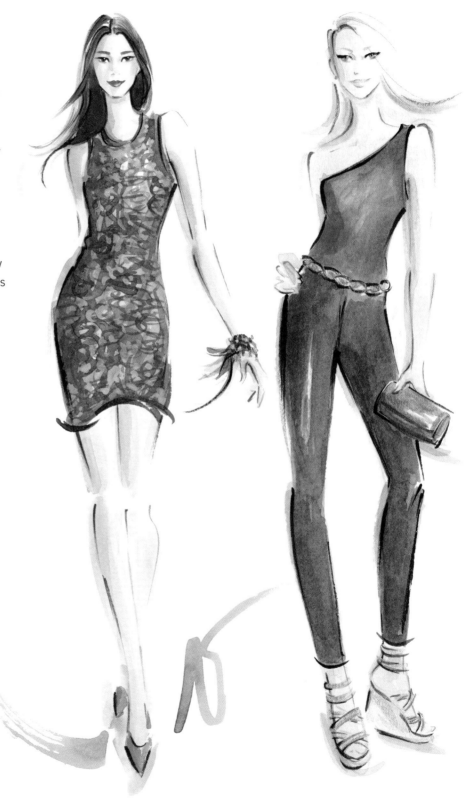

SILVER SLIVER

CLUB KITTEN

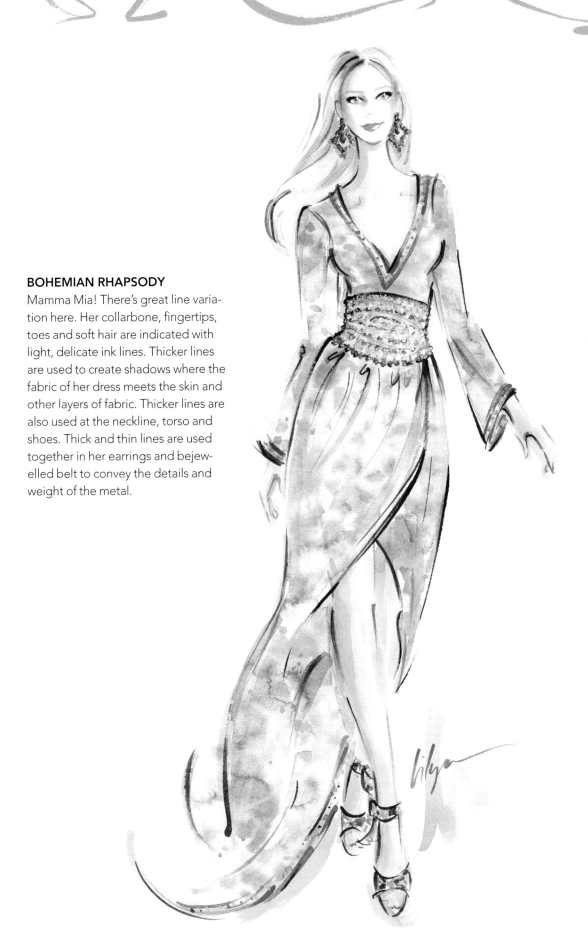

BOHEMIAN RHAPSODY

Mamma Mia! There's great line variation here. Her collarbone, fingertips, toes and soft hair are indicated with light, delicate ink lines. Thicker lines are used to create shadows where the fabric of her dress meets the skin and other layers of fabric. Thicker lines are also used at the neckline, torso and shoes. Thick and thin lines are used together in her earrings and bejewelled belt to convey the details and weight of the metal.

Visit artistsnetwork.com/fashionart to download free video demonstrations by Jennifer Lilya.

73

Alright vs. Awesome Line Quality

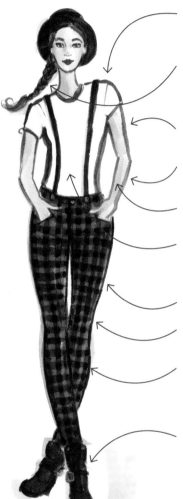

Heavy ink lines all over the illustration make it look one-noted and flat.

Too large of a brush used to paint the braid makes it dull and lack highlights.

Inelegant and sloppy linework.

Too large of a brush used for the space.

Skin tone is overworked.

White T-shirt lacks shading and fabric creases.

Needs more shading.

Line weight and texture are too uniform.

Not enough definition between the plaid squares, overall print is too dark.

Black on black lacks cool and warm details to create contrast against the neutral black outline.

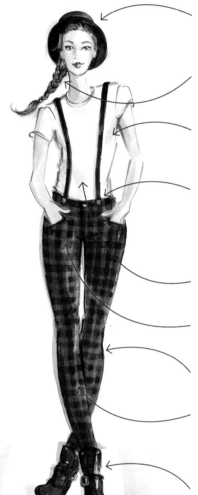

Solid black bowler hat uses light and deep shades of gray and black to convey roundness and texture.

Light ink lines convey softness and sway of the braided hair.

Soft pink lines on the T-shirt contrast nicely with the thick textured lines of wool pants.

A medium metallic effect, rather than shiny metallics, works on the buttons. Created here with Iridescent Silver mixed with a purple shading color.

Plain white T-shirt contains very light color and shading.

Quick, think ink lines show where the fabric is folded, pulled or creased.

Textured ink lines enhance cotton or wool fabrics.

The imperfectly painted plaid lets the base color and lighter elements of plaid shine through and give the effect of movement.

Straight black ink over cool black ink works well for leathers and solid black garments.

MAD AT PLAID

The one-noted, sloppy ink lines of this fashion illustration make it hard to look at it. It's obvious the lines were created with a brush that was too large for the space being painted.

MAD FOR PLAID!

Black ink is essential for creating your shapes and enhancing texture of any fashion illustration. The variation in line is what makes this girl lively, believable and happy.

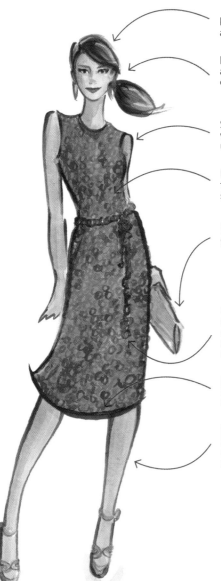

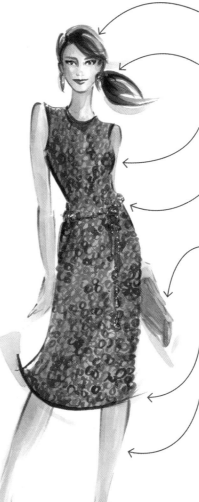

Heavy ink lines are virtually all the same weight .

Not enough contrast around the slight shading of the face and hair.

Slow, deliberate linework looks sloppy and ungraceful.

Poor line quality on the dress shows little shadow and movement.

Purse lines are smudged gray, making it look dirty.

Chain, jewelry and shoes should be a lighter tone of gold so the highlights shine through the ink and shadows.

Curved hem of the dress lacks quick tapered lines, weighing it down.

Flat skin tone and hard leg outlines make the calves and ankles look cartoonish.

Use the lightness of the paper to create highlights.

Light ink lines in the face and hair create movement and personality.

Proper shading of the dress distinguishes the waist and hips from the rest of the body.

Highlights in the chain enhance the dark gold.

The purse is light and angled to create a subtle energy that brings the image together as a whole.

Purple shadows and quick, tapered ink lines makes the dress hem lively and cute.

Variety of line, texture and color in the leg make the exaggerated movement believable and enticing.

DIS-ENCHAINTED

This part of the chain is by far the weakest link. Heavy, dull lines outline the girl, dragging her down and making her lifeless. She's flat in color and flat out boring!

ENCHAINTED!

Cute, fun and off the chain! The variety of all the different ink lines and color gradations brings this gal to life.

Visit artistsnetwork.com/fashionart to download free video demonstrations by Jennifer Lilya.

75

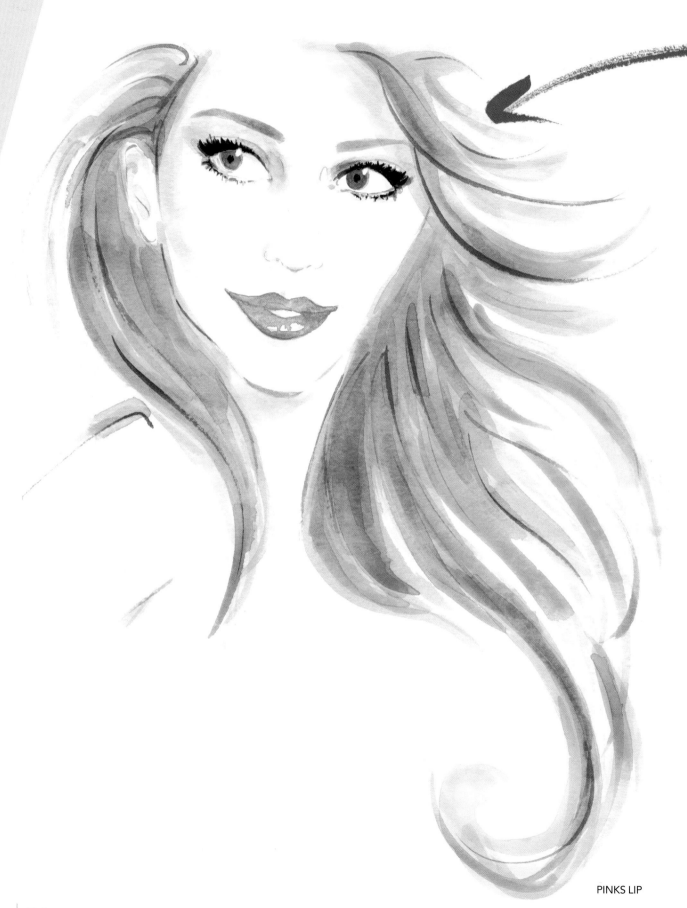

PINKS LIP

FACES

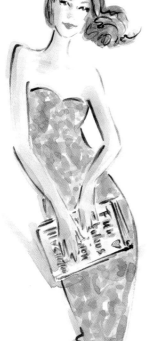

WELL RED

Faces are the most important part of all of my girls. They're the first thing you see and what draws you into the scene. My girls are always happy and why shouldn't they be? They're gorgeous, they get to wear the latest fashions, they have super fun friends, jobs and hobbies, and they're always the life of the party. You won't find any sad girls in the Lilya archives. I'm generally a happy person and that's what comes out of my brush: shiny, happy people! It's what sells the products you want to wear that make you feel fun and fabulous. Eyes are the windows to the soul, mouths say the most unexpected things and hair is pure personality on top of your head. It's simple: happy people equal happy selves, viewers and clients. Smile on!

Expressions

Most of my fashion girls have fun, happy and expressive faces, but there are other looks to capture depending on your client's wishes or what you want to paint. Here are a few examples of looks to match any attitude and pose.

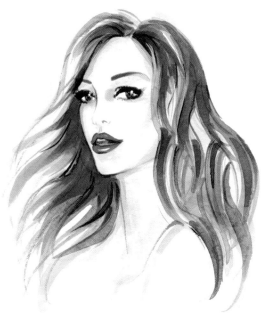

FLIRTY FUN

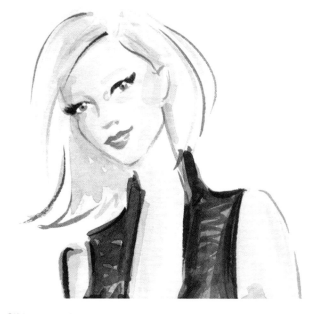

GIRL NEXT DOOR

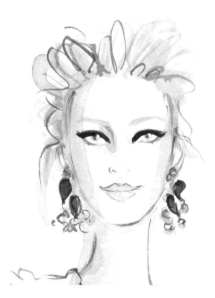

NEUTRAL NICENESS

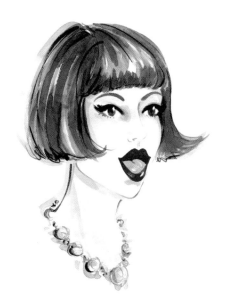

SURPRISE, SURPRISE

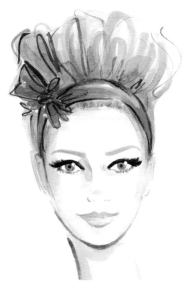

SWEETNESS AND LIGHT

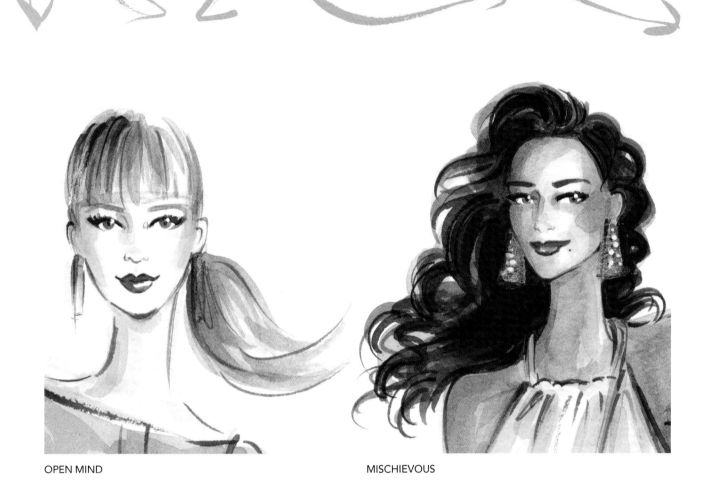

OPEN MIND

MISCHIEVOUS

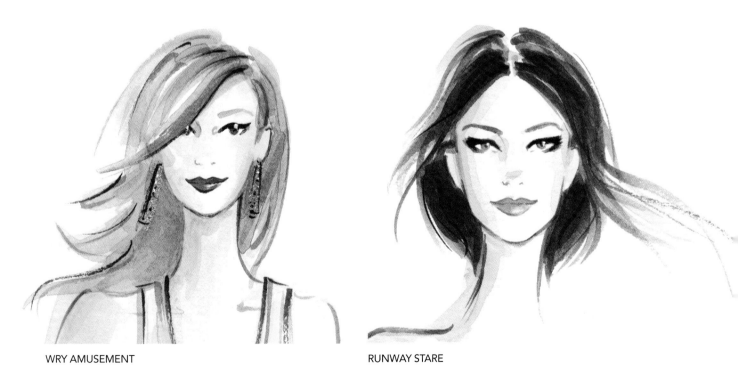

WRY AMUSEMENT

RUNWAY STARE

Visit artistsnetwork.com/fashionart to download free video demonstrations by Jennifer Lilya.

79

Lips

The lips are not the most challenging thing to depict, but their accuracy is important to achieving smiling, confident fashion girls. Curve the lips up slightly with a simple flick of the brush to indicate a smile, and leave a highlight from the paper for an extra shine.

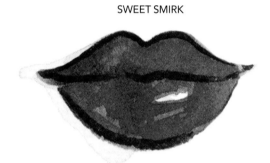

POINTED PINK

SWEET SMIRK

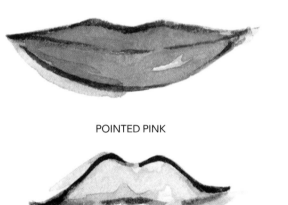

PINK PUCKER

PLUM-P

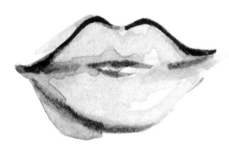

SHY SMILE

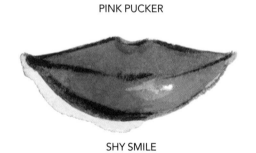

PRETTY POUT

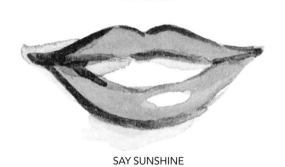

SAY SUNSHINE

RED DELICIOUS

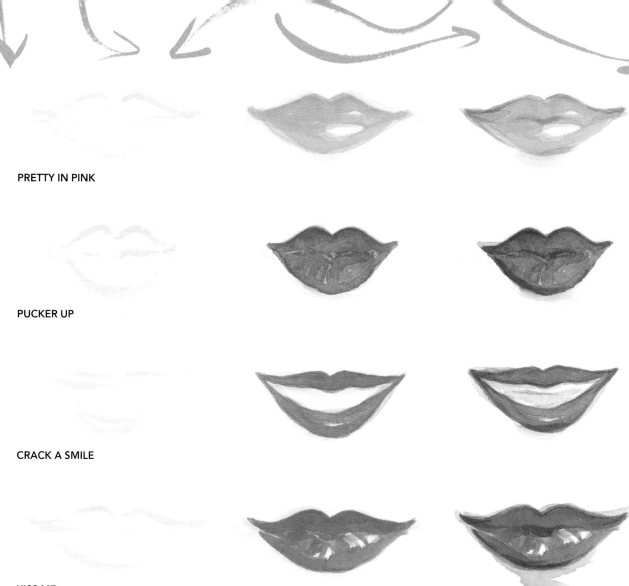

PRETTY IN PINK

PUCKER UP

CRACK A SMILE

KISS ME

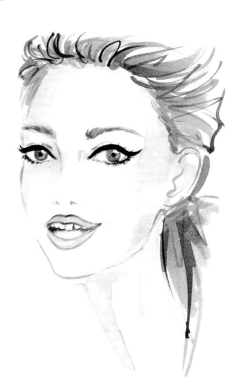

TOO MUCH TOOTH
Although it's tempting, avoid outlining the individual teeth of your fashion girls' smiles. An overly toothy grin will take away from the glamorous, loose style you've worked so hard to achieve.

Visit artistsnetwork.com/fashionart to download free video demonstrations by Jennifer Lilya.

81

DEMONSTRATION
Eyes

Eyes are the window to the soul and will truly set your girls apart. They hold the emotional weight of each expression and also depict style and glamour. Try painting the irises to one side of the eye to indicate that your girl is looking at something interesting out of view. Finish the eyes with a few long, flirty eyelashes using a 000 brush, black ink and a quick tapering technique.

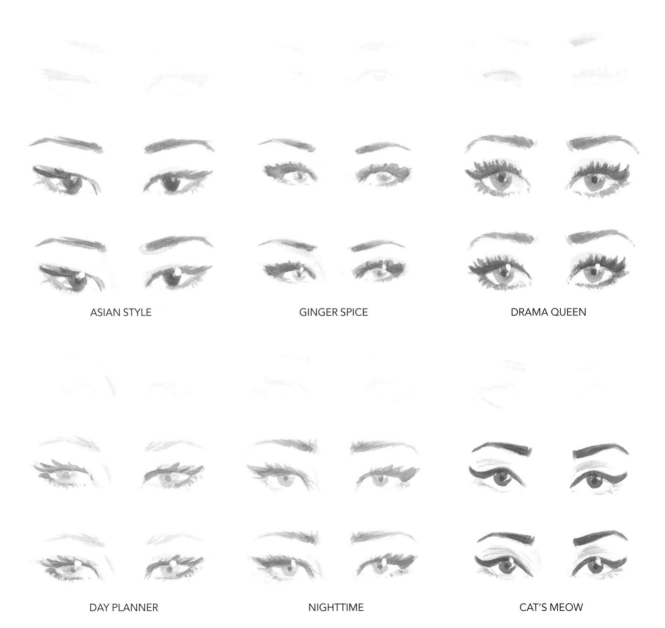

ASIAN STYLE

GINGER SPICE

DRAMA QUEEN

DAY PLANNER

NIGHTTIME

CAT'S MEOW

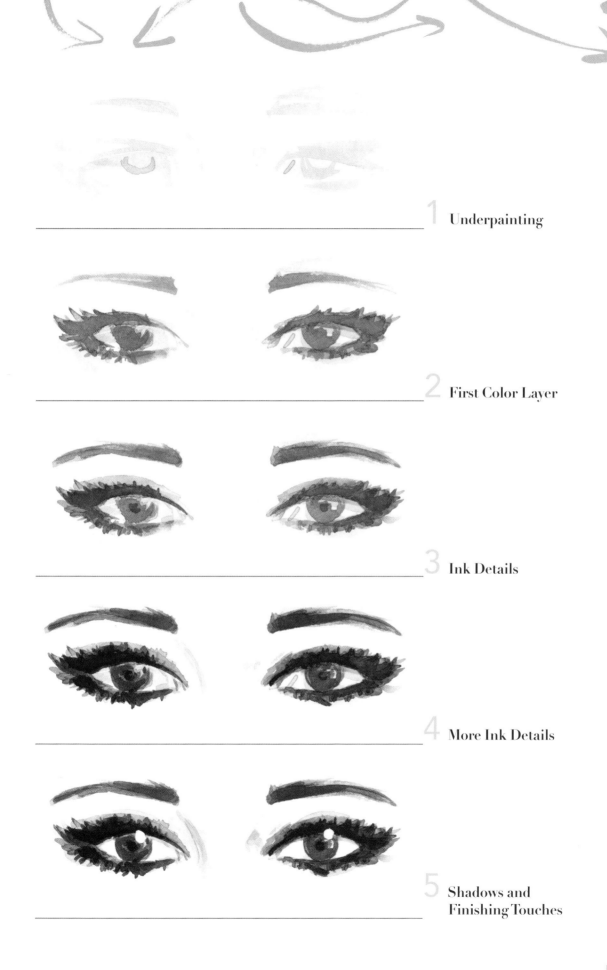

1 Underpainting

2 First Color Layer

3 Ink Details

4 More Ink Details

5 Shadows and
Finishing Touches

Visit artistsnetwork.com/fashionart to download free video demonstrations by Jennifer Lilya.

83

DEMONSTRATION
Noses

In reality noses are somewhat complex, but in a fashion illustration you want to keep them simple and pretty. You need just a couple of lines to indicate the nose. The same principle can be applied to ears as well.

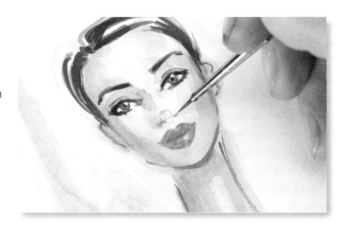

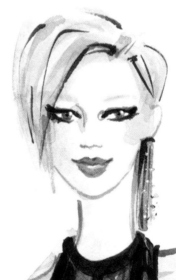

ALRIGHT VS. AWESOME
The upturned nose on the left conveys a snobby attitude and the open nostrils create unsightly holes in the face. On the right, soft lines indicate roundness, which imparts sweetness, and the nostrils are hidden for an elegant look.

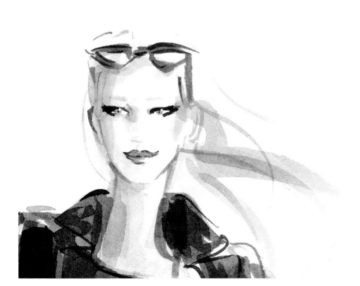

NOSE CREATED WITH COLOR SHAPES

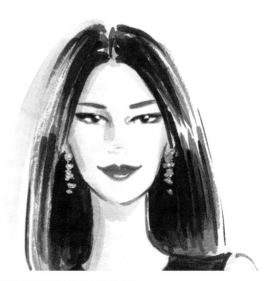

NOSE CREATED WITH SIMPLE LINES

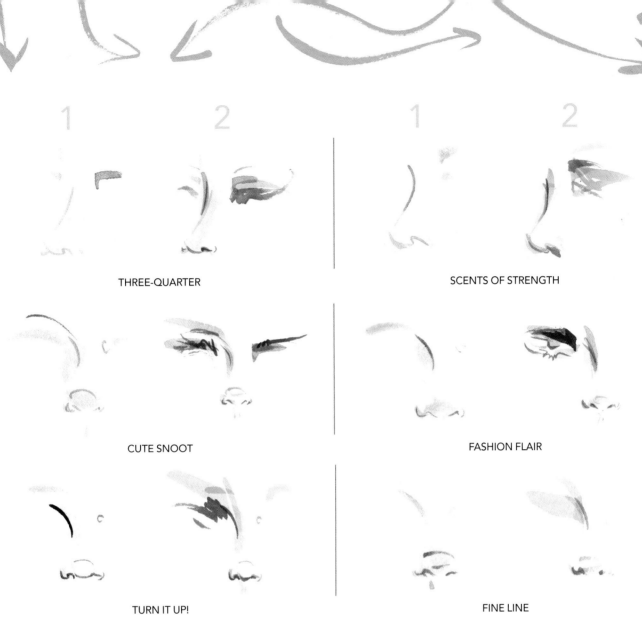

THREE-QUARTER

SCENTS OF STRENGTH

CUTE SNOOT

FASHION FLAIR

TURN IT UP!

FINE LINE

GOOD NOSE EXAMPLES

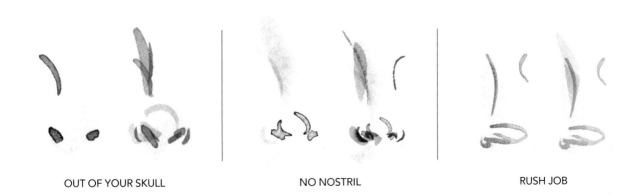

OUT OF YOUR SKULL

NO NOSTRIL

RUSH JOB

BAD NOSE EXAMPLES

Visit artistsnetwork.com/fashionart to download free video demonstrations by Jennifer Lilya.

85

Alright vs. Awesome Faces

Here are a few examples of alright vs. awesome face and hair combinations. Compare the simple mistakes and easy fixes to help you achieve the freshest fashion faces around!

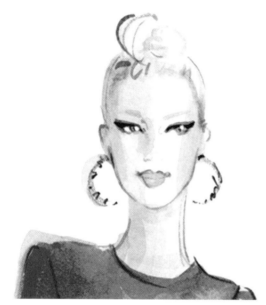

SIGH UPDO

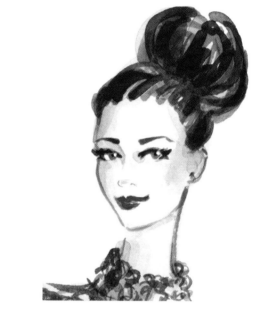

FLY UPDO

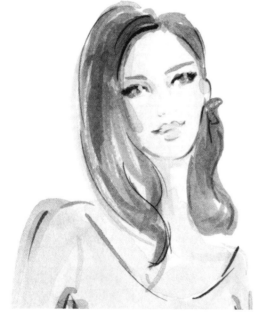

VACANT GAZE

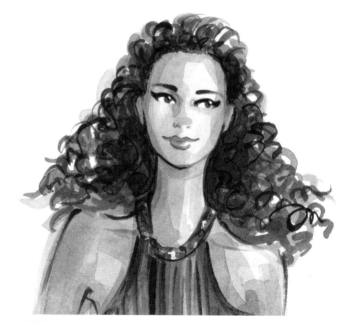

CURIOUS GAZE

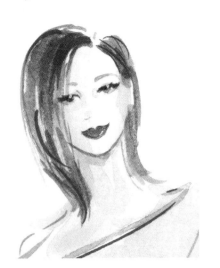

MELLOW SAD

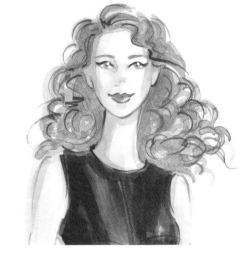

MELLOW SWEET

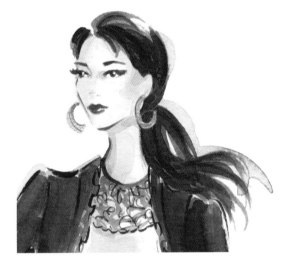

SERIOUSLY MEAN

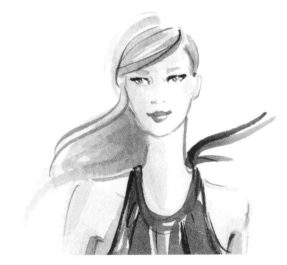

SERIOUSLY SWEET

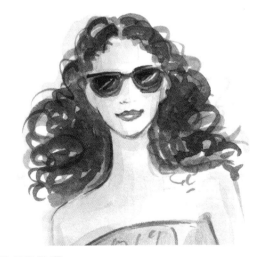

DULL AND FLAT

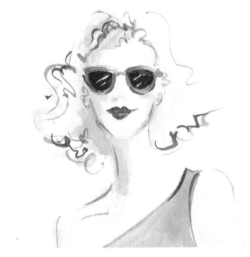

BOUNCY AND BRIGHT

Visit artistsnetwork.com/fashionart to download free video demonstrations by Jennifer Lilya.

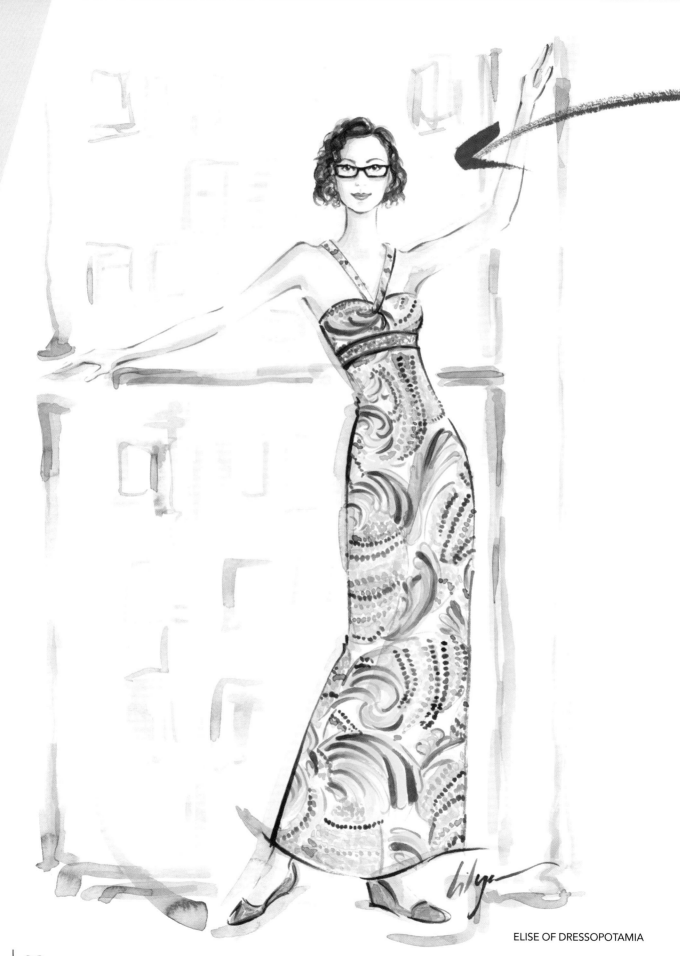

ELISE OF DRESSOPOTAMIA

FABRIC & ACCESSORIES

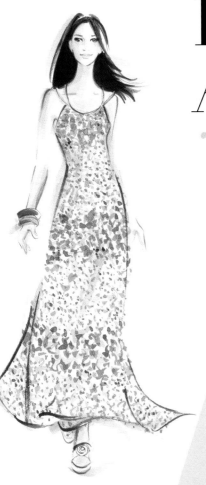

LA VIE BOHEME

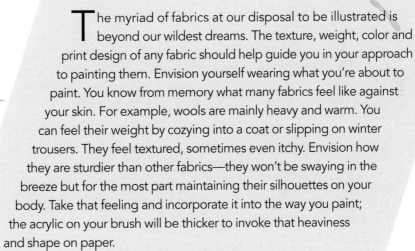

The myriad of fabrics at our disposal to be illustrated is beyond our wildest dreams. The texture, weight, color and print design of any fabric should help guide you in your approach to painting them. Envision yourself wearing what you're about to paint. You know from memory what many fabrics feel like against your skin. For example, wools are mainly heavy and warm. You can feel their weight by cozying into a coat or slipping on winter trousers. They feel textured, sometimes even itchy. Envision how they are sturdier than other fabrics—they won't be swaying in the breeze but for the most part maintaining their silhouettes on your body. Take that feeling and incorporate it into the way you paint; the acrylic on your brush will be thicker to invoke that heaviness and shape on paper.

The Importance of Clothing

The way your illustrated girls wear clothing is beyond important. Seams, size and fabric draping all come into play just like they do in real life. One tends to look sloppy or worse when her clothes don't fit well on her body. Illustrations that overlook proper fit and fabric movement will also look the same. On the other hand, women who know what looks best on their figures look completely put together and confident.

The importance of tailoring in reality and on paper can't be stressed enough. Pay attention to the lines that seams create and where clothing should sit on a body. The creases and folds created during different poses or walking should also be taken into consideration when painting any fabrics. Garments look different on a hanger than they do on a woman. It's up to you to make them look fabulous no matter where they're hanging! Here are a few examples of properly fitted clothing and the details that make it appear that way!

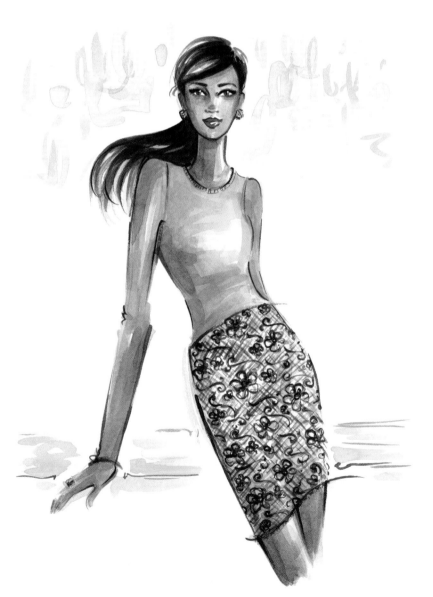

DRAPING THE FABRIC
Simple contrasting textures create visual interest in any illustration. A solid cotton knit top is painted with just the slightest of texture, where highlights meet the color of the fabric and where shadows are painted to create roundness and depth. Just a few strokes of layered color will create the illusion of cotton knit fabric wrapped around a body. Envision yourself pulling on a similar top or garment—you can turn that feeling right into an illustration. As the body moves here, you may catch glimpses of lace on skin where the lining moves away from the hem of the skirt. You'll want to paint skin tone in that area to create a sense of the model's body through the fabric. Sheer genius!

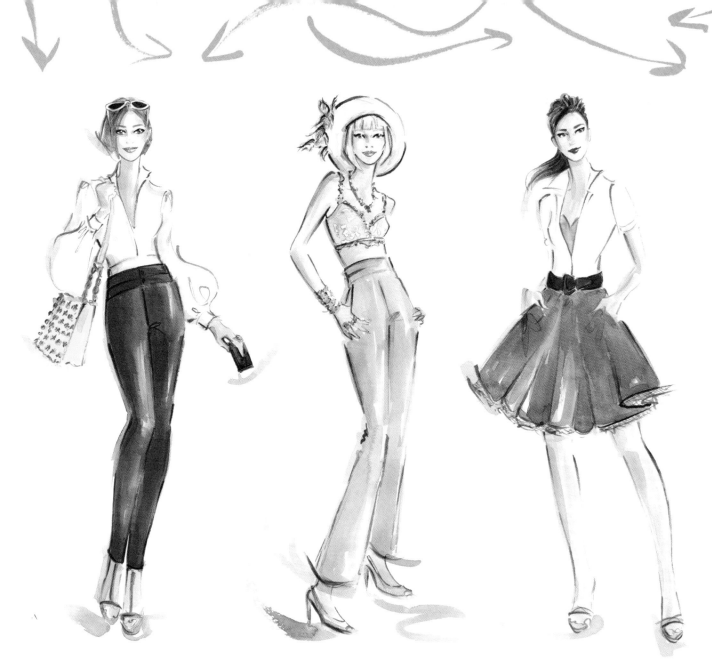

PERSIMMON GRANTED

Persimmon Granted is ripe for the picking. Her sunnies are inserted into her hair rather than awkwardly sitting atop her head. Her top and pants are formfitting but not overly tight. Her studded bag bounces off her hip while she walks. Her phone is angled away from her, an added angle to get the most movement out of small shapes. A few highlights keep the solid color from looking flat. The gold T-straps with one foot in a walking stance are a nice complement to the gold studs and jewelry. Just juicy!

ROCK CANDI

Rock Candi is sweet, cool and confident from head to toe. Extra texture and shading helps her hat appear floppy around the edges. Her pants flare out in straight lines where Candi pulls down on the pockets. This tension is a nice complement to the softness of the overall illustration. Fabric creases behind the knees are indicated with just a few tight scribbles. Too few creases and the fabric won't drape, too many and the illustration will look overworked. Pay close attention to the shapes that fabrics create while circling the body.

PINKY PARFAIT

Pinky's 1950s flair is classic feminine fun. Her ponytail is pulled away from her face to highlight the popped collar. The seam of her cotton blouse creates the action line of her arm. An open blouse can add movement by exposing a bustier top—two simple wavy lines will unbutton any blouse. The wide belt cinches her waist beautifully where the fabric begins to gather. Hands in pockets create movement by adding volume to the skirt fabric. A simple open sandal matches her bustier and contrasts the heaviness of the skirt above. She's ready for a dance-off!

Visit artistsnetwork.com/fashionart to download free video demonstrations by Jennifer Lilya.

91

Fabric

The way fabric is painted on a body will make or break your girls. You can get the texture, print and colors just right, but if the fabric doesn't move with the body, the viewer won't believe the girl's wearing clothing that fits well. Everything will look flat and off if the fit is wrong. Your goal is to make the clothing look alive, wrapping around the body with curved lines and proper shading, hems that shape themselves against the skin and draping that glides in the air rather than falls flat.

STRIKING OLD

There's a gold mine of mistakes in this illustration. Her left earring's gold chain is falling unnaturally compared to her stance. The straight neckline makes the fabric look stiff and flat. A visual hint of the upper arm is missing underneath the clothing, making it appear as though she's missing an arm. The lack of highlights in the skirt punches a black hole of dullness into the page. The harsh curve of the hem makes it look like she's unnaturally leaning forward and about to fall over.

STRIKING GOLD

This gold dust woman has all the right moves. Her shawl flows along with her shoulders down to the exaggerated folds of the bottom hem. The viewer needs to see all the little gathered folds of the draping neckline; otherwise the wide bottom hem isn't believable. Even though her right arm is hidden, you know it's there because of the way her upper arm shape is painted in. The variation of color intensity in the boots, the skirt and the flow of the hem over each thigh let the viewer know it's a formfitting garment.

Prints

Prints are fun to paint, but translating them to the human form can pose a challenge. Each line of a plaid has to wrap around the body, stripes have to remain even, each printed shape has to move gracefully atop the body's curves, and the painted print fabric has to cling against and drape off the body in a believable way. Be sure to read the fine print so you don't overlook highlights, construction and details. Side-by-side examples of figures wearing prints will help you gather details for your own textile message.

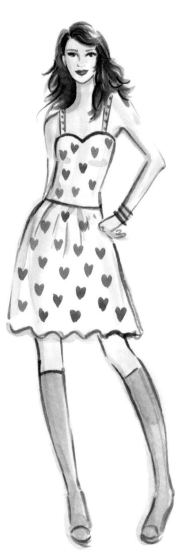

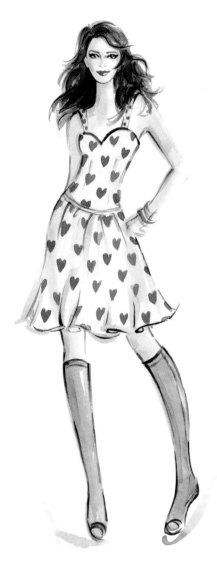

BROKEN-HEARTED
This gal is feeling a little worse for wear. Her shoulder straps are too straight rather than curving over her shoulders and clavicles. The fabric at the waist should show more gathers to enhance its cut and swing. All of this is compounded by the poor placement of the heart print pattern. The hearts are haphazardly placed along the dress, making it look flat and lifeless.

HEART IN THE RIGHT PLACE
This gal is looking healthy and happy. There's a consistent line quality used from head to toe that naturally emphasizes movement and realness. Her sassy waist twist and the pattern of her dress move nicely along with the contoured shoulder straps, and the hearts curve around the bodice following her natural action line. The hearts are painted around her body just like the fabric is wrapped around her.

Visit artistsnetwork.com/fashionart to download free video demonstrations by Jennifer Lilya.

DEMONSTRATION
Plaid

From grunge to glam, lumberjacks to clans, plaid never goes out of style! Create a colorful pattern by overlapping layers of color until you've built up a plaid worthy of rock stars, classic girls or city slickers.

RAD PLAID!

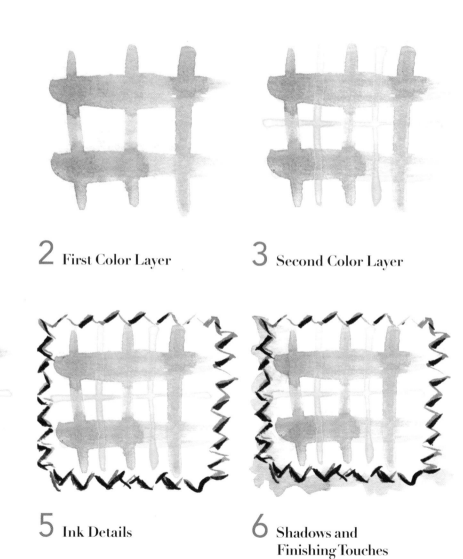

1 Underpainting

2 First Color Layer

3 Second Color Layer

4 Third Color Layer

5 Ink Details

6 Shadows and Finishing Touches

DEMONSTRATION
Floral Print

If you need inspiration for florals, look no further than your own backyard. No backyard? Take a walk in a community garden, pick up a fashion magazine or stroll into a flower shop. For intricate and specific flowers, pick up a reference book of botanicals that will serve you well for your entire blooming career.

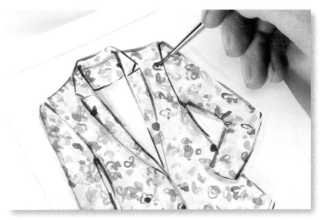

FLOWER POWER!

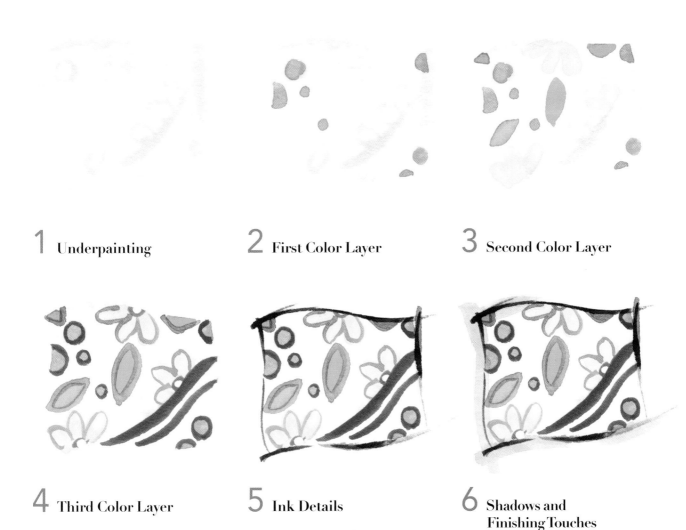

1 **Underpainting**

2 **First Color Layer**

3 **Second Color Layer**

4 **Third Color Layer**

5 **Ink Details**

6 **Shadows and Finishing Touches**

Visit artistsnetwork.com/fashionart to download free video demonstrations by Jennifer Lilya.

95

DEMONSTRATION
Leather

Leather spans both the ages and the styles. Think classic Birkin bags and motorcycle jackets to glamour girls and punk rock pinups. Shiny highlights and deep lowlights are perfect for depicting leather, which is one of the most versatile materials around.

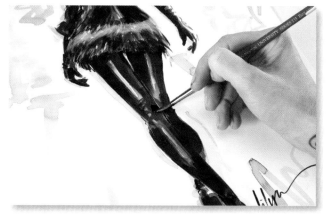

HOLY COW!

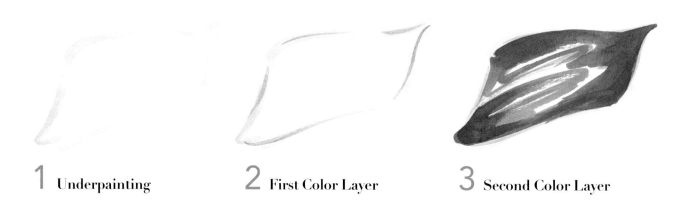

1 **Underpainting**

2 **First Color Layer**

3 **Second Color Layer**

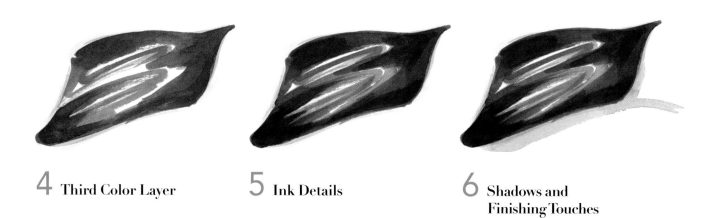

4 **Third Color Layer**

5 **Ink Details**

6 **Shadows and Finishing Touches**

DEMONSTRATION
Silky Sheen

Soft silks and chiffons are breezy and beautiful to illustrate and wear. Think of fabrics blowing in the wind, translucent enough for light to shine through. To paint silk, you want to use your paintbrush in the same way. Light, loose layers of color made with wide, flowing strokes will translate that soft energy onto the paper.

SHEER GENIUS!

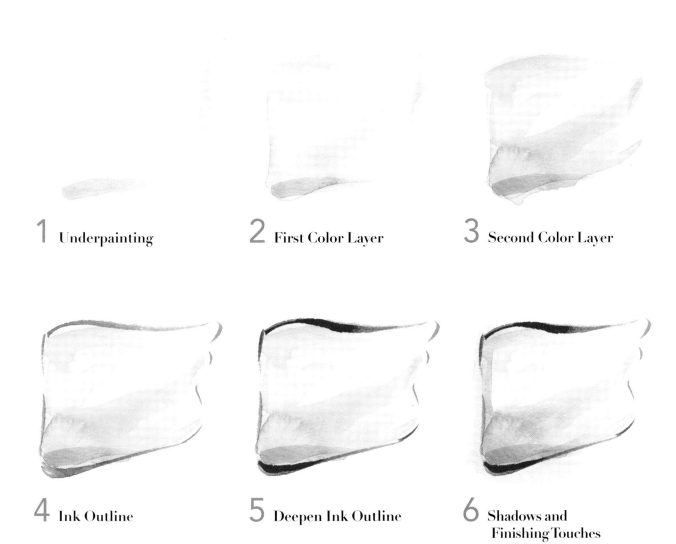

1 **Underpainting**

2 **First Color Layer**

3 **Second Color Layer**

4 **Ink Outline**

5 **Deepen Ink Outline**

6 **Shadows and Finishing Touches**

Visit artistsnetwork.com/fashionart to download free video demonstrations by Jennifer Lilya.

97

DEMONSTRATION
Lace

Lace can be used in many different ways. From dainty and elegant to pop-star pizazz to bridal beauty. It takes patience to build up the layers of color and line to create the pattern and edging of lace. Take your time. It's not a race to illustrate your lace!

WHAT A FRILL!

1 Underpainting

2 First Color Layer

3 Second Color Layer

4 Third Color Layer

5 Ink Details

6 Shadows and Finishing Touches

DEMONSTRATION
Metallics

Metallic fabric can range from casual knits, lively lace and futuristic acetates to costume lamés, shiny spandex and cool cocktail dresses. For eye-catching glamour, grab some Iridescent Bright Gold, Iridescent Silver and Iridescent Pearl (all by Golden) for turning colored material into shiny gems.

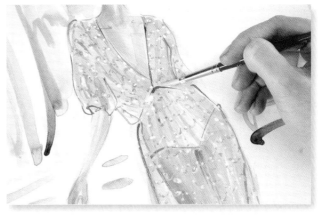

METALLIC-AAAH!

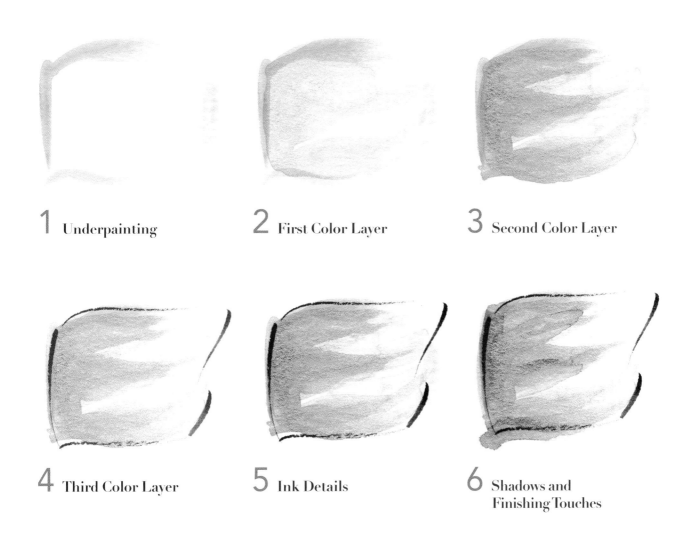

1 Underpainting

2 First Color Layer

3 Second Color Layer

4 Third Color Layer

5 Ink Details

6 Shadows and Finishing Touches

Visit artistsnetwork.com/fashionart to download free video demonstrations by Jennifer Lilya.

99

DEMONSTRATION
Tweed

Tweed is a classic fabric, but it doesn't have to be old and stodgy. Think updated herringbone vests with a white tee and leggings or a vintage tweed jacket paired with distressed denim and heels. The dry brush technique is your best friend when it comes to painting tweeds. Start with plaid's painting basics, then add dryer layers of color for the final coats and edging.

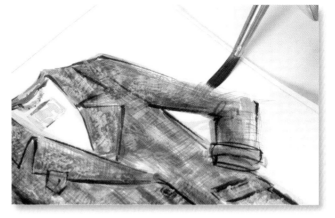

TEXTURE MESSAGE!

1 Underpainting

2 First Color Layer

3 Second Color Layer

4 Third Color Layer

5 Ink Details

6 Shadows and Finishing Touches

DEMONSTRATION
Fur

Furs can be anything from luxurious to practical to fun. Whether you're painting real fur or fake fur, your technique is going to be the same—lots and lots of little lines built up to create the lush fabric.

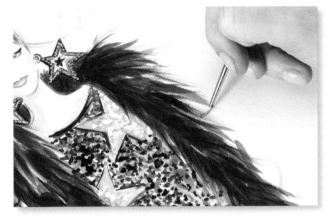

FAUX REAL!

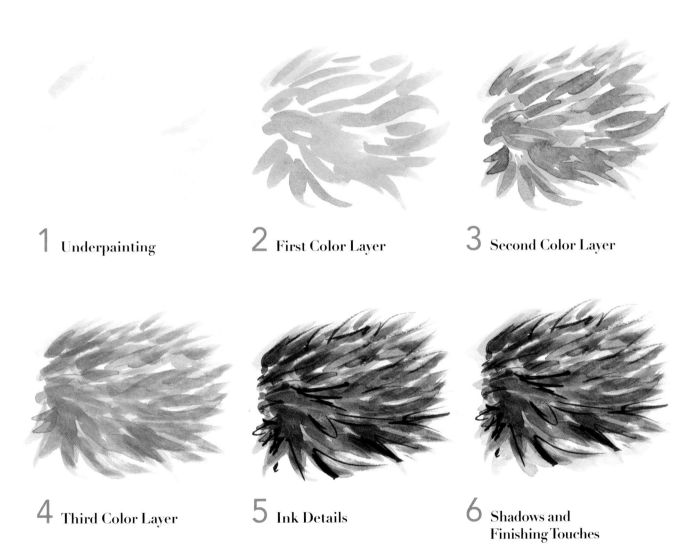

1 Underpainting

2 First Color Layer

3 Second Color Layer

4 Third Color Layer

5 Ink Details

6 Shadows and Finishing Touches

Visit artistsnetwork.com/fashionart to download free video demonstrations by Jennifer Lilya.

Shoes

Close your eyes and imagine a closet full of
shoes of your favorite fashion: stilettos, kitten
heels, flats, wedges, boots and pumps. It's a
blast to depict them all!

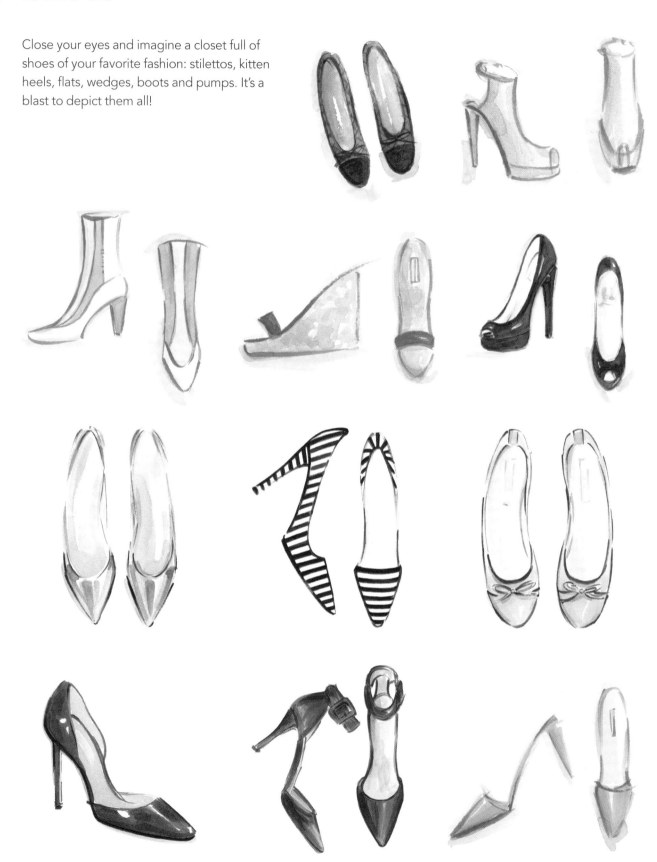

Jewelry

You could paint jewelry twenty-four hours a day for a year and still not paint all the different types. The earrings and necklaces I give my fashion girls are loose and stylized. Try to focus on painting the idea of the pieces, not every detail.

Visit artistsnetwork.com/fashionart to download free video demonstrations by Jennifer Lilya.

103

Bags

Whatever you prefer to call it—purse, clutch, satchel, handbag, pocketbook, tote, or even simply the name of the designer—a bag is the perfect accessory for the hippest fashion girls. Check out current fashion mags and blogs as often as you can for up-to-date inspiration.

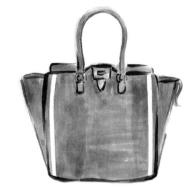
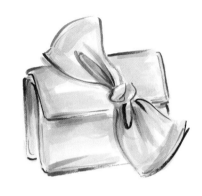

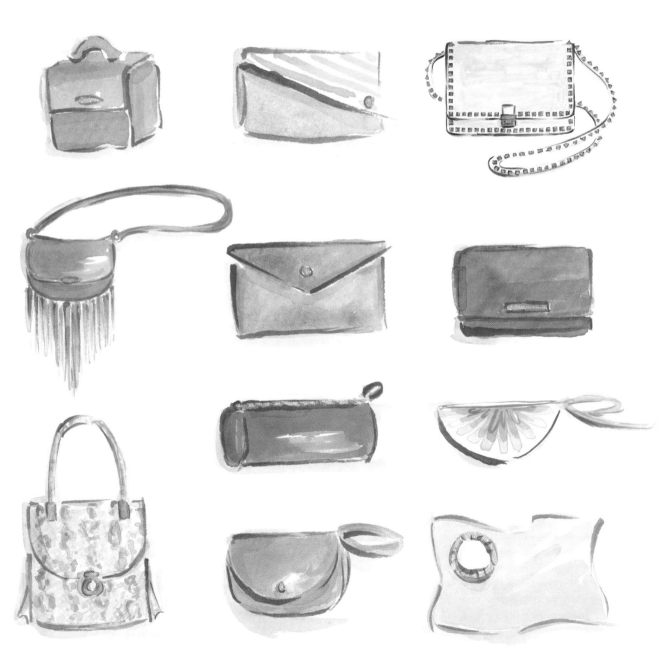

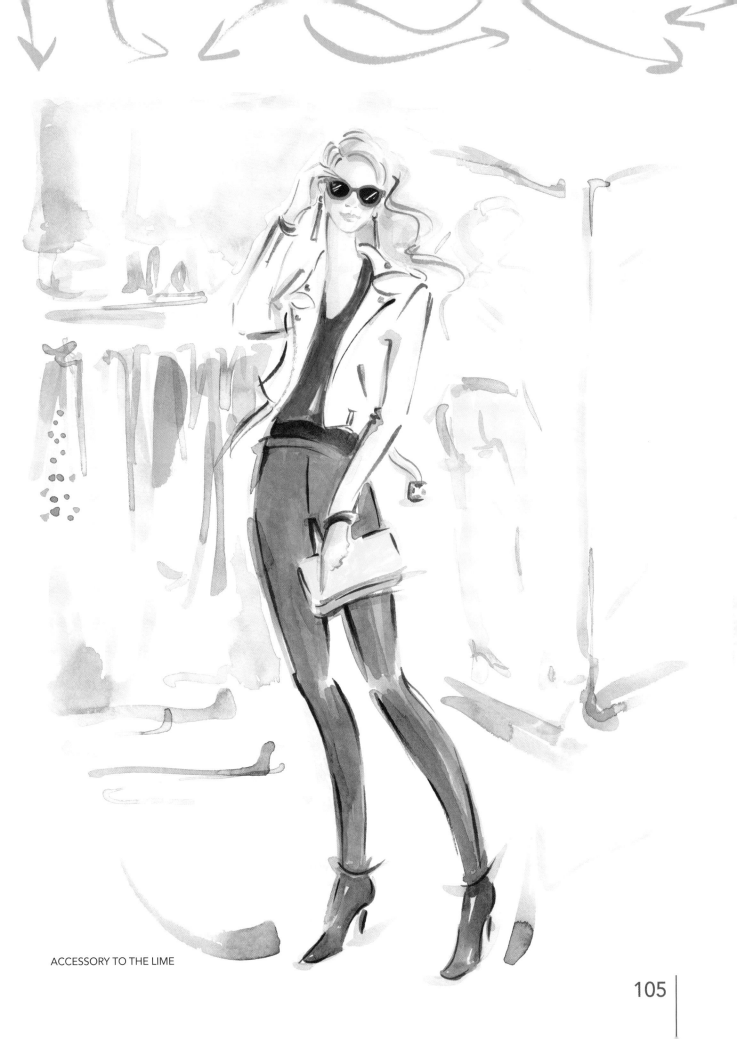

ACCESSORY TO THE LIME

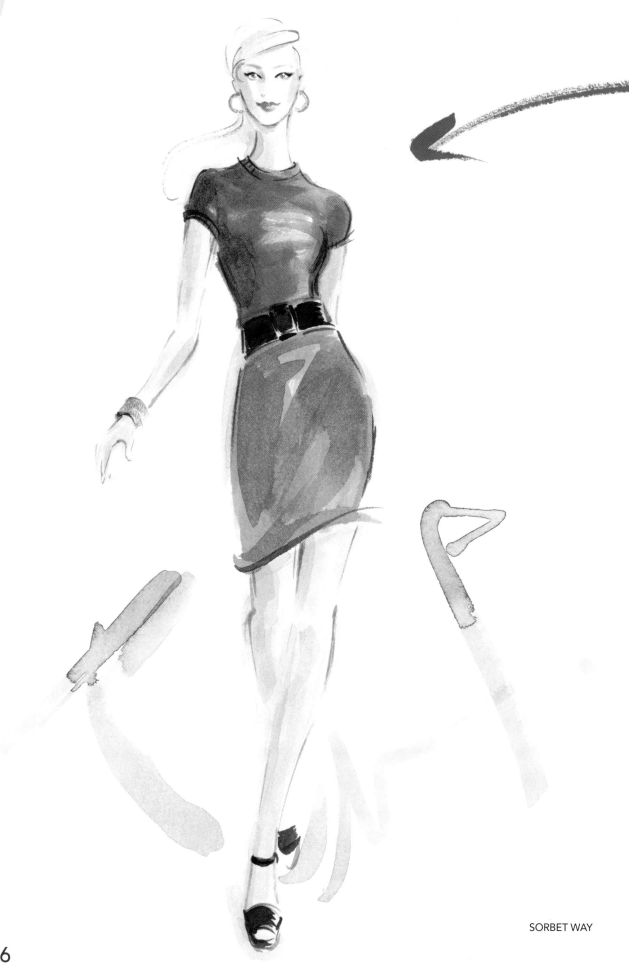

DEMOS, GALLERY & TEMPLATES

MINTY FRESH

And now for the finale! Step by step, color by color, line by line—it's time to bring together all of the lessons and tips of the book into illustrations with your own style and personality. Paint what inspires you. It's not always an option when working with clients, but at the very least you can find portions of any illustration—hair, styling, color, background scene—that can give you the inspiration you need to finish a piece to perfection.

When working on your own portfolio pieces, paint what you love. Your portfolio will show clients what moves you as well as your ability to translate a vision to paper. The best illustrations are the ones that come naturally and that you don't have to think too much about. The art simply flows from your brush, and the result is a beautiful piece full of line and color. It's obvious when an artist is in love with their work or, unfortunately, when they've struggled with something by overworking it or using too tight of a line.

Anytime you have an idea for a painting or a fun title pops into your head, write it down immediately. You may not use it right away, but all of your notes will come in handy when you need an extra boost of inspiration on a slow day.

Best wishes and happy painting!

SeaGurl

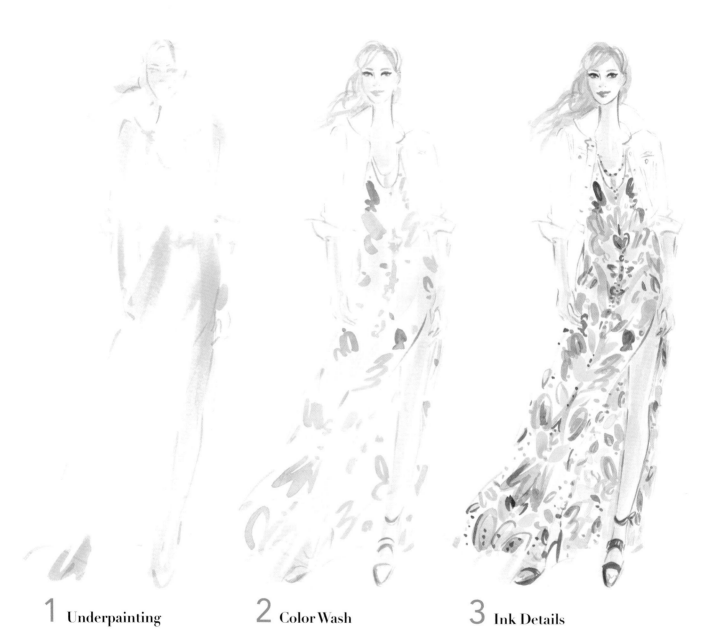

1 **Underpainting**

2 **Color Wash**

3 **Ink Details**

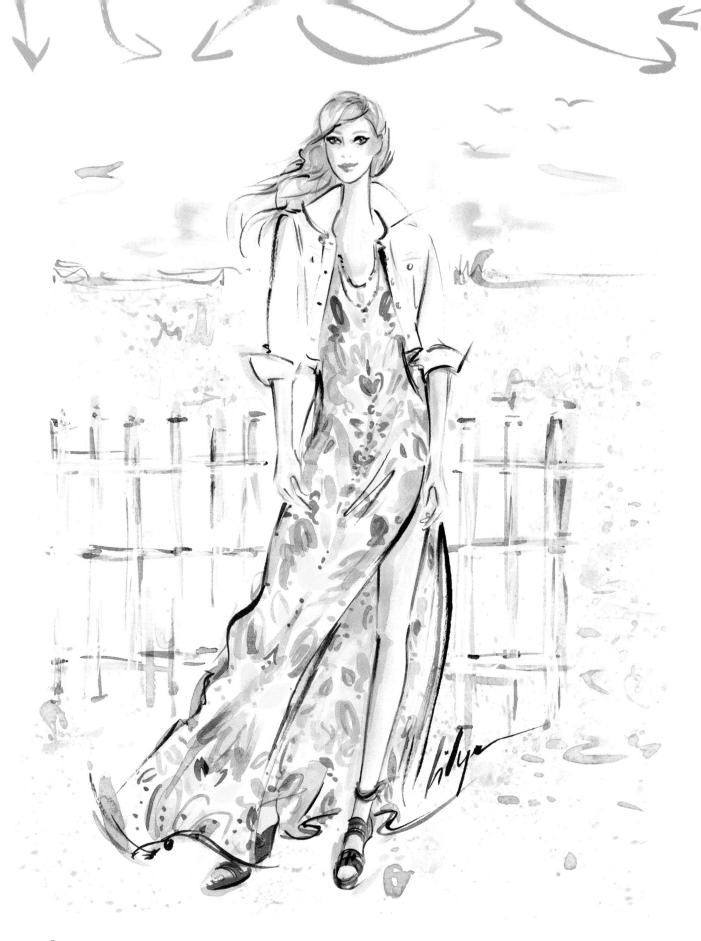

4 Shadows and Finishing Touches

Visit artistsnetwork.com/fashionart to download free video demonstrations by Jennifer Lilya.

109

Blossom Forth

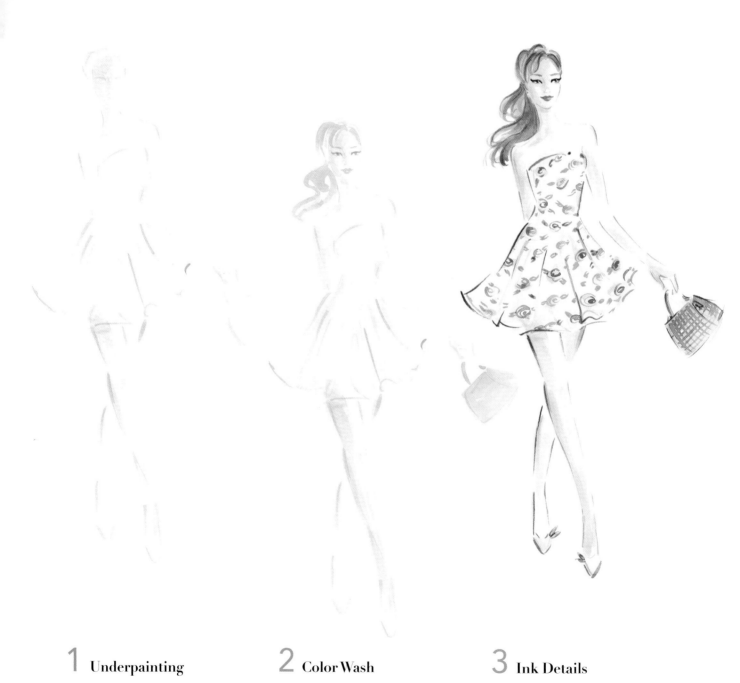

1 Underpainting 2 Color Wash 3 Ink Details

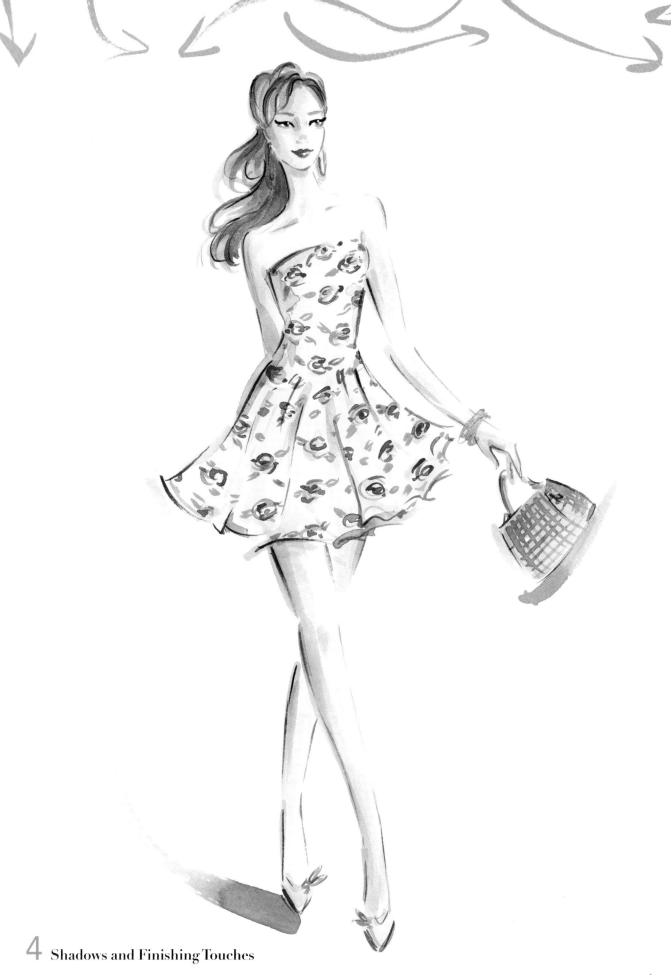

4 Shadows and Finishing Touches

Visit artistsnetwork.com/fashionart to download free video demonstrations by Jennifer Lilya.

111

DEMONSTRATION
Green-Eyed Glamour

1 Underpainting

2 First Color Layer

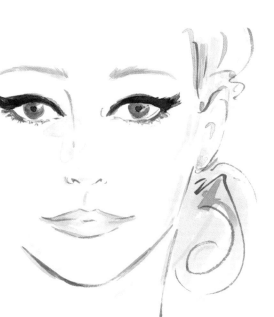

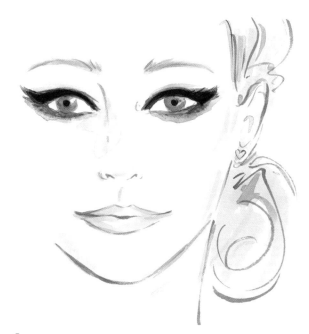

3 Second Color Layer

4 Ink Details

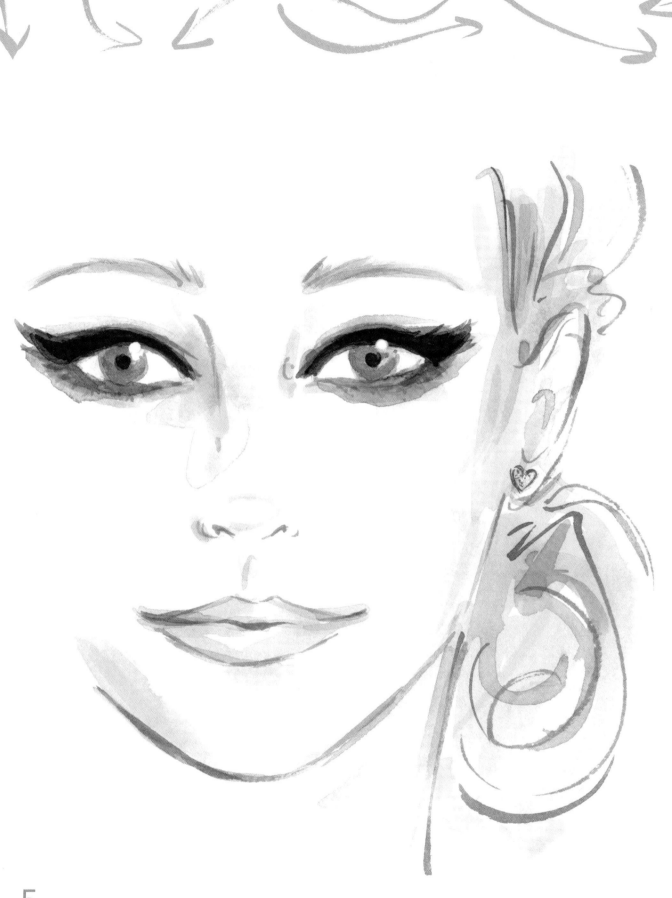

5 Shadows and Finishing Touches

Red-Lipped Radiance

1 **Underpainting**

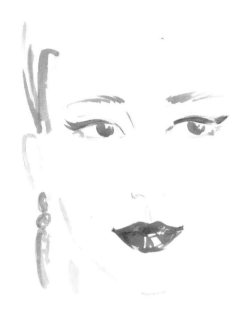

2 **First Color Layer**

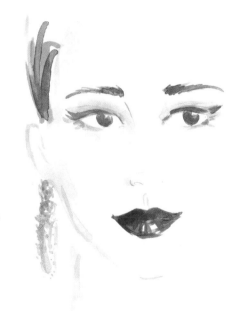

3 **Second Color Layer**

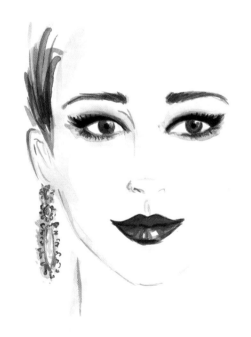

4 **Ink Details**

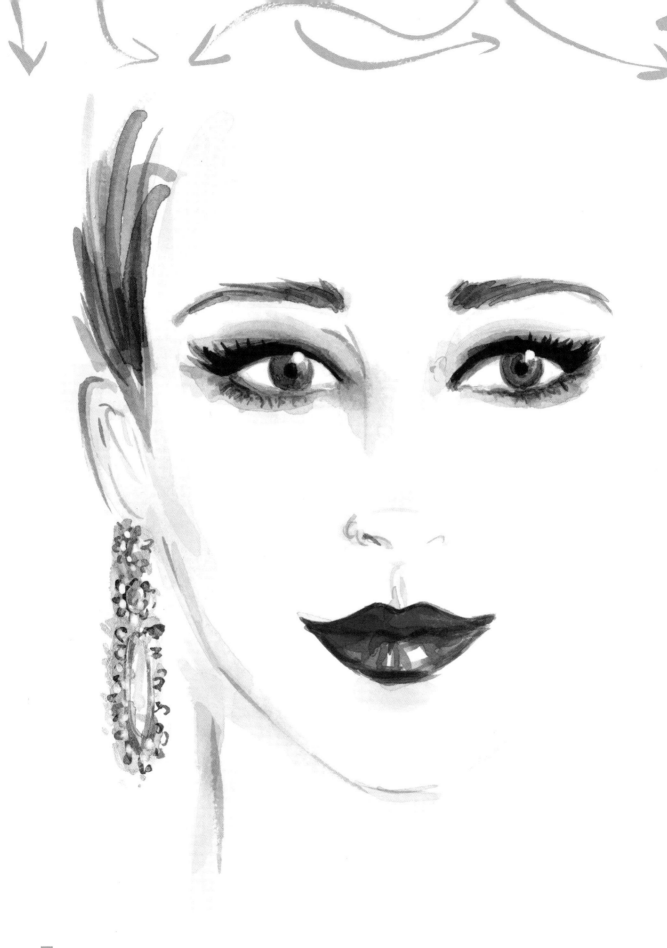

5 Shadows and Finishing Touches

Visit artistsnetwork.com/fashionart to download free video demonstrations by Jennifer Lilya.

115

DEMONSTRATION
Daphne

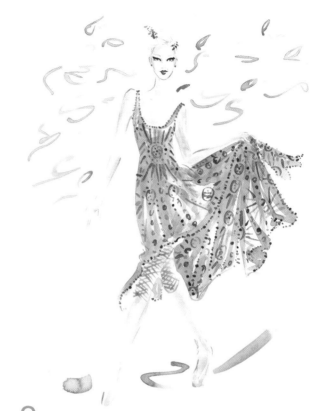

1 Underpainting

2 Color Wash

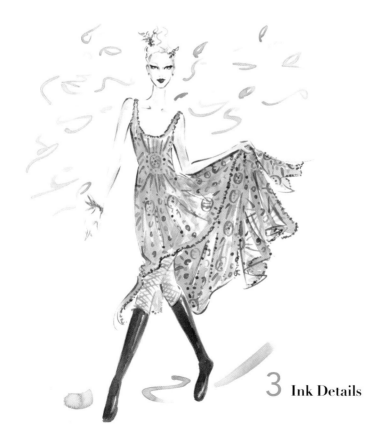

3 Ink Details

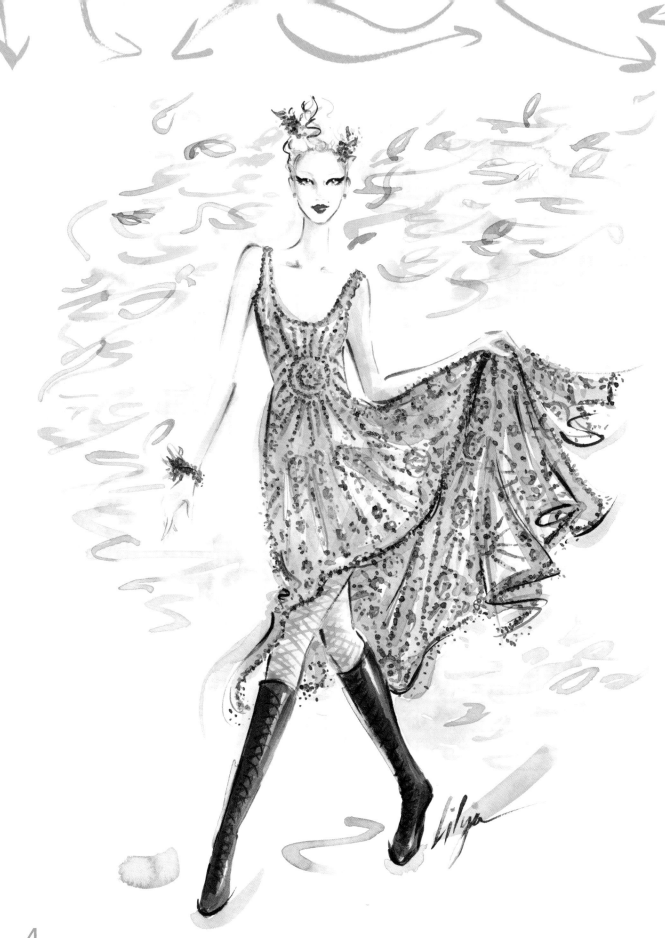

Visit artistsnetwork.com/fashionart to download free video demonstrations by Jennifer Lilya.

117

The Monochromes

1 Underpainting

2 Color Wash

3 Ink Details

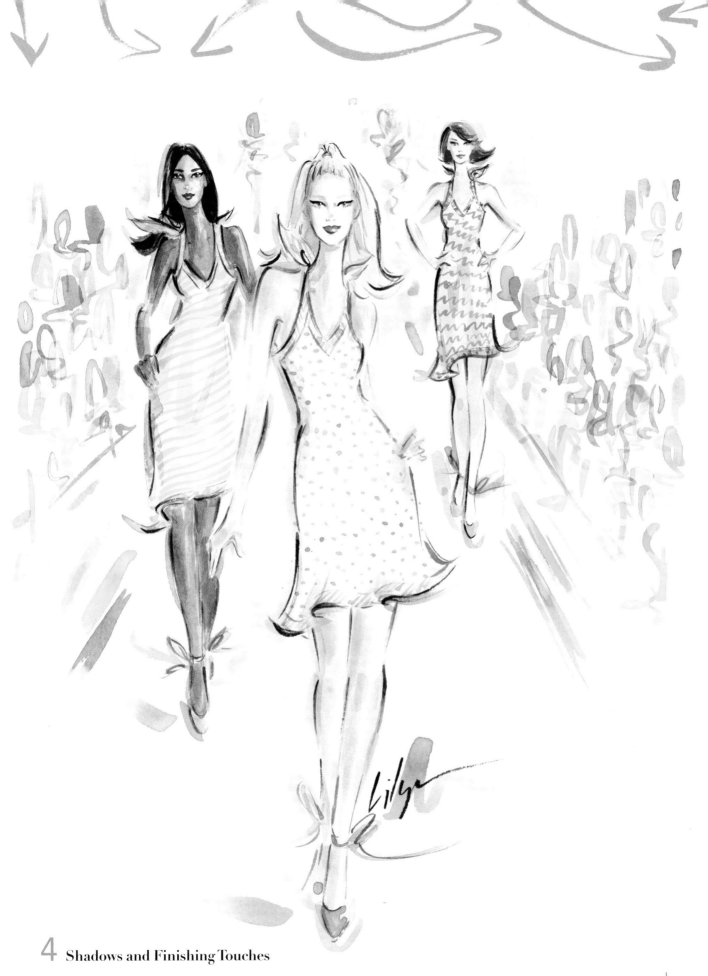

4 Shadows and Finishing Touches

Visit artistsnetwork.com/fashionart to download free video demonstrations by Jennifer Lilya.

119

Gallery

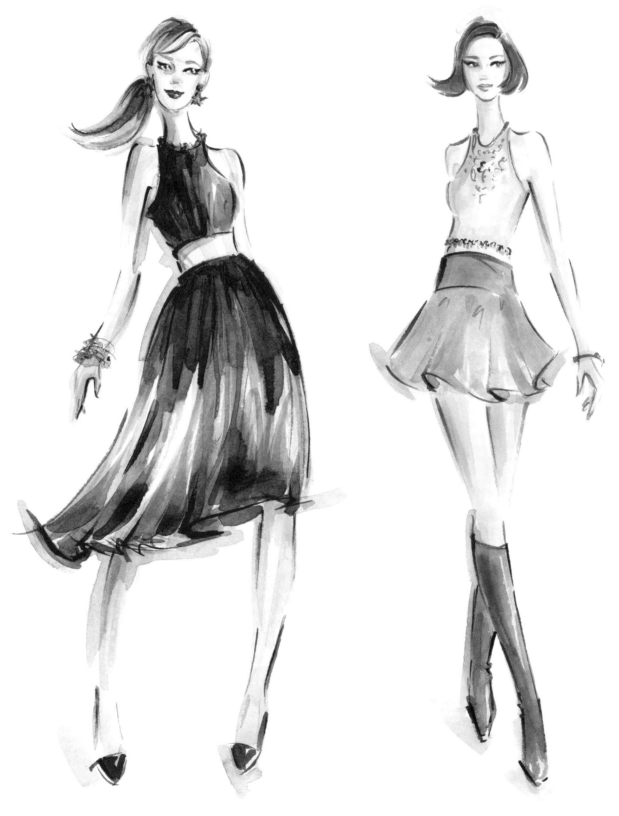

BLUE JAY SWAY

MINI MOUSE

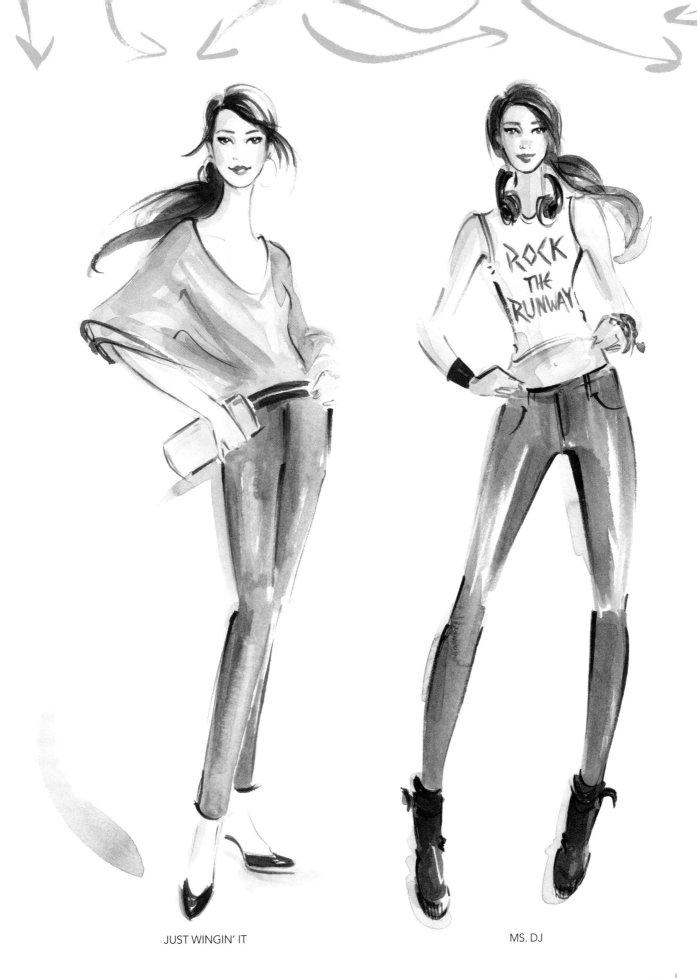

JUST WINGIN' IT

MS. DJ

Visit artistsnetwork.com/fashionart to download free video demonstrations by Jennifer Lilya.

121

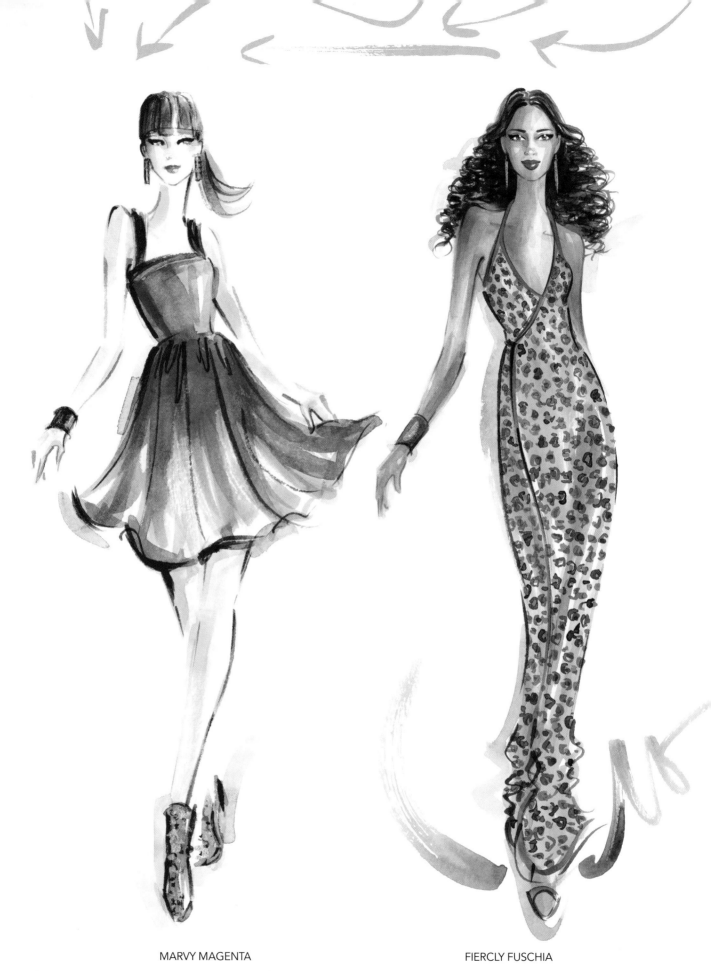

MARVY MAGENTA

FIERCLY FUSCHIA

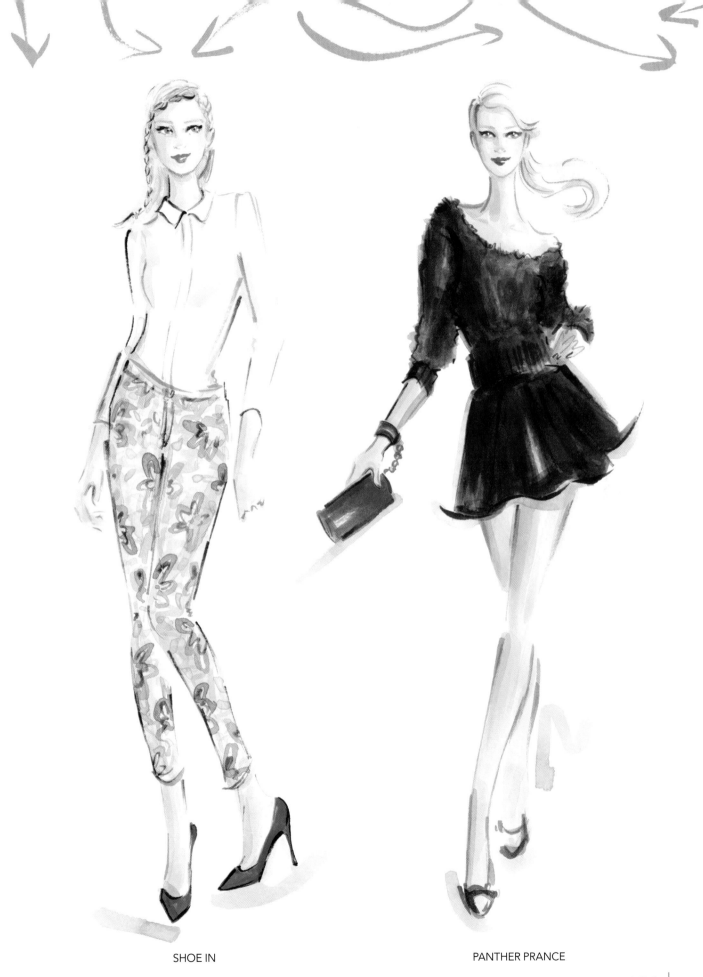

SHOE IN

PANTHER PRANCE

Visit artistsnetwork.com/fashionart to download free video demonstrations by Jennifer Lilya.

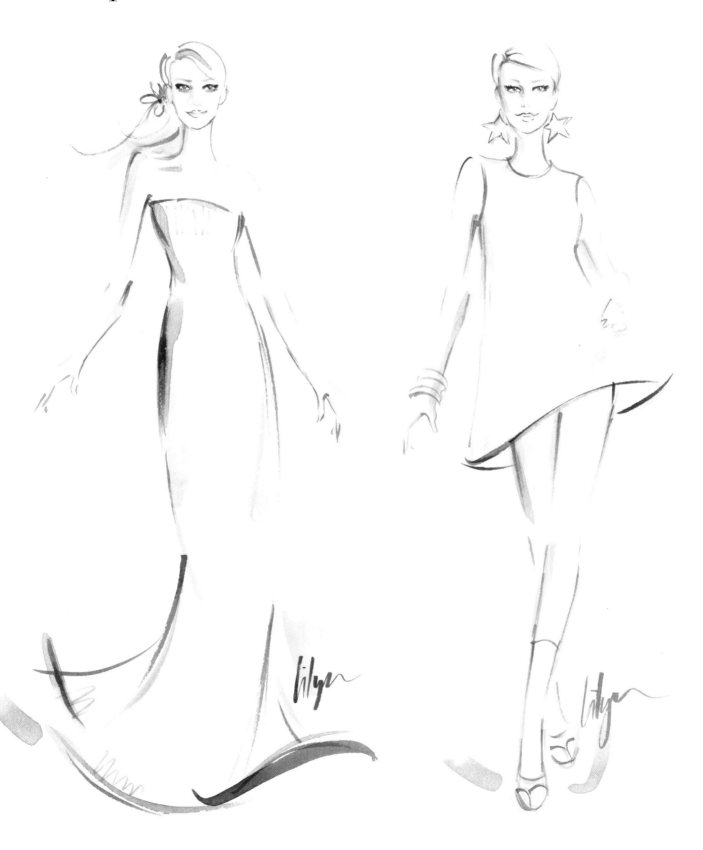

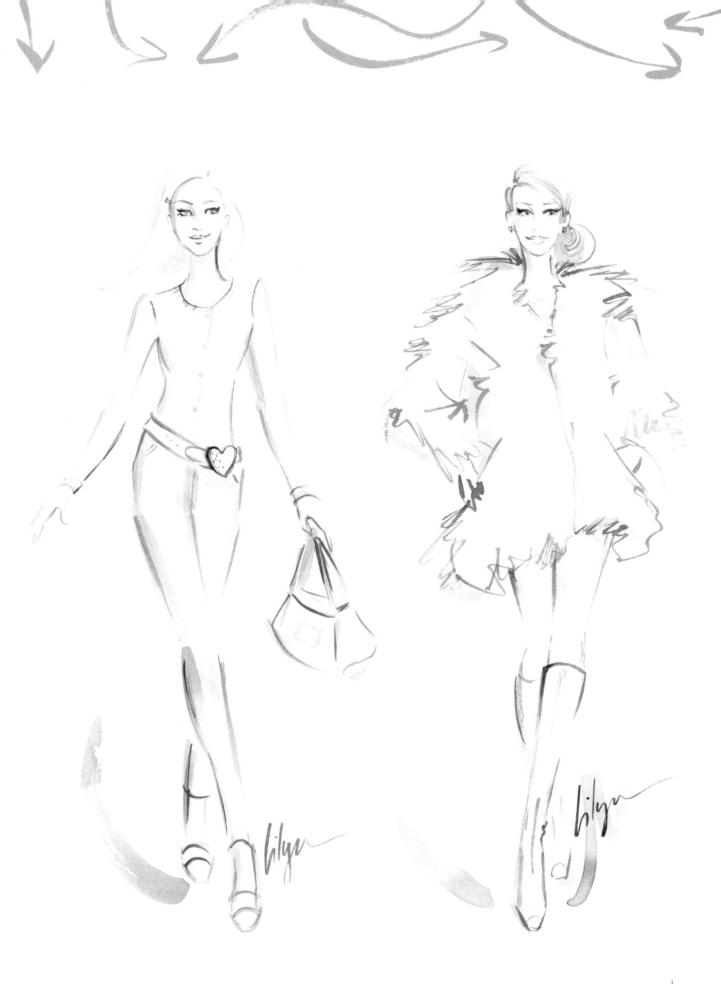

Index

accessories, 89, 102–105
acrylic paint, 10–11
action lines, 38–39
anatomy basics, 28

bags, 104–105
balance, 27, 34–35
blotting, 66–67
brush care, 10
brushes, 4. 9, 10
 loading, 67
 selection of, 65
brushstrokes, 64
brushwork, 66–67

clothing, 90–91
color drop effect, 18
color mixing, 15
 for eyes, lips and hair, 16–17
 opaque vs. translucent, 66
color theory, 14
color wash technique, 19
color washes,
 creating movement with, 58–59
 creating shapes with, 46–47
complementary colors, 14
concentrated color technique, 19

demonstrations
 eyes, 82–83
 floral print, 95
 fur, 101
 highlights and shadows, 20-21
 lace, 98
 leather, 96
 lips, 80–81
 metallics, 99
 movement, creating 56–57, 58–59
 noses, 84–85
 plaid, 94
 silk, 97
 tweed, 100
drawing ink, 11–12
dry brush technique, 19

emotion, conveying with lines, 71
exaggeration, 49, 54–55, 70
expressions, 78–79
eyes, 82–83
 color mixing for, 17

fabric, 89
 draping, 90
 form-fitting, 92
 fur, 100
 lace, 98
 leather, 96
 metallics, 99
 plaid, 94
 prints, 93, 95
 silky sheen, 97
 tweed, 100
faces, 77–85
figures
 anatomy basics, 28
 back-facing view, 33
 balanced, 27
 correcting bad balance, 34–35
 correcting poor proportion, 34–35
 front-facing, 31
 natural movement, 30
 side view, 32
 standing, 29
 three-quarter view, 32
fur, 101
fur effect, 19

gallery, 120–123
gesture painting, 37–45
gestures, alright vs. awesome, 44–45
hair, color mixing for, 17
highlights, 16, 20–22

ink, drawing, 11–12
ink lines, 70

jewelry, 103

lace, 98
leather, 96
lighting, 12, 21
line quality, 63
 good vs. bad, 74–75
line weight, 71
lines, conveying emotion with, 71
linework, 72
lips, 80–81
 color mixing for, 16

materials, 4, 10–13
metallics, 99
mise en place, 9

movement, 49–53, 56–59, 70
 alright vs. awesome, 60–61
 and brush size, 65

noses, 84–85

overworking, 61, 68–69

paint and pigments, 4, 9
 acrylic, 10–11
 allowing to dry, 47
palette, 11, 13
paper, 11–12
paper towels, 12
plaid effect, 19, 94
portfolio, 107
poses
 with attitude, 52–53
 casual, 50–51
 stiff, 56–57
primary colors, 14
proportion, 34–35
 exaggerated, 54–55

recycling, 12, 67
reference, using self as, 20

secondary colors, 14
shading, 72
shadows, 20–21
shapes, simple, 40–41
shoes, 102
skin tones, 22
 color combinations, 24–25
 full body poses, 23
spiral sketches, 42–43
splatter effect, 19
spray bottle, 12
supplies, 4, 10–13
surfaces, 4, 9, 11–12

teeth, 81
templates, 124–125
tertiary colors, 14
tools, 4

water jars, 12
workspace, 12

Photo by Covington Portraits

About the Author

Jennifer Lilya grew up in Fairfield, Connecticut, where she spent countless hours sketching her Barbie dolls and still does to this day! Barbie, Fashion Plates and '80s pop culture influenced her love of fashion and art, inspiring her to move to NYC to attend the Fashion Institute of Technology (FIT), where she majored in Fashion Illustration. She specializes in fashion illustration in acrylics and black ink on paper. Her combination of fashion art and witty hand-lettering gives her pieces a whimsical, modern edge. Jennifer has been illustrating professionally since 1993. Her love of runway sketching and her traditional, non-digital approach to illustration has garnered her numerous clients including *ELLE*, Katy Perry, Barneys NY, Dolce & Gabbana, Stila Cosmetics, *WWD*, Bloomingdale's, Saks Fifth Avenue, dELiA*s, Edelman PR, Neiman Marcus, Mood Fabrics, Dove, American Airlines, among many other brands, fashion designers and publications. Visit her website at **jenniferlilya.com**.

a content + ecommerce company

Other fine North Light Books are available from your favorite bookstore, art supply store or online supplier. Visit our website at fwcommunity.com.

18 17 16 15 14 5 4 3 2 1

DISTRIBUTED IN CANADA BY FRASER DIRECT
100 Armstrong Avenue
Georgetown, ON, Canada L7G 5S4
Tel: (905) 877-4411

DISTRIBUTED IN THE U.K. AND EUROPE
BY F&W MEDIA INTERNATIONAL LTD
Brunel House, Forde Close, Newton Abbot, TQ12 4PU, UK
Tel: (+44) 1626 323200, Fax: (+44) 1626 323319
Email: enquiries@fwmedia.com

DISTRIBUTED IN AUSTRALIA BY CAPRICORN LINK
P.O. Box 704, S. Windsor NSW, 2756 Australia
Tel: (02) 4560-1600; Fax: (02) 4577 5288
Email: books@capricornlink.com.au

ISBN 13: 978-1-4403-3543-3

Edited by Sarah Laichas
Designed by Elyse Schwanke
Production coordinated by Mark Griffin

Acknowledgments

I couldn't have finished this book without the love, help, support and fun from the following amazing people in my life:

Dennis Hayes: The best husband in the world. Thanks for putting up with my all night painting parties and dealing with a missing wife for the better part of a year. I love you. Perfect.

My family: Thank you, Mom and Dad, for first of all sending me to FIT, and for your endless support and encouraging words to get me through my sleepless hours. Not to mention new shawls, food goodies, pet-sitting and lots and lots of tea. Matt, Wendy, Tyler and Max—thank you for the backyard fireworks, rock band fun times and monkey shenanigans!

My friends: Thank you to everyone who sent me messages 24/7, helping to keep me awake and motivated throughout this project! Thanks for hanging out when my schedule would allow, helping me relax and have fun outside of my studio! Thanks for the music mixes, funny comments, random outings and all around love that I get every single day from all of you awesome people in my life.

Christian Medina: Thank you for taking on my least favorite part of the job—the dreaded digital scan cleaning. You sweetly dealt with my crazy hours and deadlines, sending me art that was print-ready to go! In the process you gave me inspiration and I'm happy to have a new friend!

Tweak: Thank you for being the meanest, sweetest puppy ever. The late night walks, grrrs and cuddles kept me going and provided nonstop entertainment during marathon painting sessions.

Sarah Laichas: Thank you for being such a sweet and patient editor, dealing with my crazy outside deadlines and complete slowness at everything but painting! You're a saint.

My social media friends: Thank you to complete strangers and new friends from all over the world for following my work! The emails, comments and art you send make me endlessly happy and inspired. Please keep them coming!

I love you all. Thank you! xoxo

Ideas. Instruction. Inspiration.

Receive FREE downloadable bonus materials when you sign up for our free newsletter at artistsnetwork.com/Newsletter_Thanks.

Find the latest issues of The Artist's Magazine on newsstands, or visit artistsnetwork.com.

These and other fine North Light products are available at your favorite art & craft retailer, bookstore or online supplier. Visit our websites at artistsnetwork.com and artistsnetwork.tv.

Follow North Light Books for the latest news, free wallpapers, free demos and chances to win FREE BOOKS!

Visit artistsnetwork.com and get Jen's North Light Picks!

Get free step-by-step demonstrations along with reviews of the latest books, videos and downloads from Jennifer Lepore, Senior Editor and Online Education Manager at North Light Books.

Get involved
Learn from the experts. Join the conversation on